LOST COUNTRY HOUSES OF
SOUTH AND WEST YORKSHIRE

IAN GREAVES

AMBERLEY

This edition first published 2024

Amberley Publishing
The Hill, Stroud
Gloucestershire GL5 4EP

www.amberley-books.com

Copyright © Ian Greaves, 2024

The right of Ian Greaves to be identified as the Author
of this work has been asserted in accordance with the
Copyrights, Designs and Patents Act 1988.

All rights reserved. No part of this book may be reprinted
or reproduced or utilised in any form or by any electronic,
mechanical or other means, now known or hereafter invented, including
photocopying and recording, or in any information
storage or retrieval system, without the permission in writing
from the Publishers.

British Library Cataloguing in Publication Data.
A catalogue record for this book is available from the British Library.

ISBN 978 1 3981 1634 4 (print)
ISBN 978 1 3981 1635 1 (ebook)

Typesetting by Hurix Digital, India.
Printed in Great Britain.

Introduction

Apart from Winifred Holtby's classic novel, there is no South Riding. If there had been, it would probably have included that part of the Yorkshire south of the Leeds–Bradford conurbation containing the towns of Barnsley, Doncaster and Rotherham and the city of Sheffield. This area, along with the industrial cities of Leeds and Bradford and towns like Wakefield, Dewsbury, Huddersfield and Halifax, presents the classic image of industrial Yorkshire. However, the West Riding is strikingly diverse and also includes Ripon, Knaresborough and beautiful Wharfedale.

Unsurprisingly given its role in the Industrial Revolution, due to the availability of coal, water and labour, the losses of country houses in all these areas have been considerable, particularly in the areas now covered by the major towns and cities. These losses fall broadly into three groups: the characteristic manor houses of the valleys around Leeds and Bradford, usually built on wealth from the first phase of the Yorkshire textile boom; the mansions of their descendants, the nineteenth-century textile and industrial magnates; and a smaller group of houses belonging to the landed aristocracy or gentry, who depended on their estates for survival. Their relatively small size and the fact that the wealth of their owners derived from trade rather than landed property has meant that many West Yorkshire gentry houses have survived.

Significant losses have occurred, at least two with Brontë connections, demolished before their literary associations could save them. Inevitably the grandiose mansions of the Victorian industrial giants have fared less well. Not one survives as the seat of the family that built it, though few were of architectural significance. Had the best – Castle Carr, Milner Field, Oakworth Hall – survived a little longer they might have enriched the bland redevelopment of these now post-industrial areas.

In the last group there are four houses of national significance: Kippax Park, Kirby Hall, Methley Hall and Sprotborough. Although a number of houses in West Yorkshire have been convincingly ascribed to Robert Smythson, only Heath Old Hall survived into modern times and it too has gone. Two grand ducal houses – Kiveton and Howley – are also long lost. Industrialisation, urbanisation and subsidence have taken a considerable toll on the domestic architecture of West Yorkshire.

The list of houses included in this book is as complete as I have been able to establish. The choice has inevitably been subjective: when is a mill owner's mansion a country house rather than a suburban villa? The selection of illustrations has been limited by space and the availability of good-quality images. The available information about individual houses is often conflicting, especially in terms of ownership, but I hope the brief histories I have given are accurate. Amongst the

stories of these houses are poets, painters, artists, murderers and martyrs, not to mention a selection of ghosts and apparitions. Between them they offer multiple snapshots of almost 1,000 years of Yorkshire history.

I would be delighted to receive new information, illustrations or corrections at ian@doctors.org.uk. I am particularly interested to hear of houses I have managed to miss. Equally I would be delighted to provide further information and images on request when I have them. All the author's royalties from this book will support architectural conservation charities.

Ackton Hall, Featherstone

Ackton was the seat of the Featherstone family from the twelfth to the early fifteenth century, when the Featherstone heiress married one of the Frost family from Normanton. In its final form Ackton Hall was an early seventeenth-century building. The property was bought by Thomas Wynn and enlarged in 1765 with a seven-bay front and three-bay pediment. Ackton passed to Wynn's son, Sir Edmund, and then to his great nieces who sold it in 1865 to George Bradley. When Bradley died in 1896, the house was sold to a T. Middleton of Leeds. A later owner, Mr Lister, converted the house for multiple ownership and, after a period of decay, Ackton Hall was demolished in 1969.

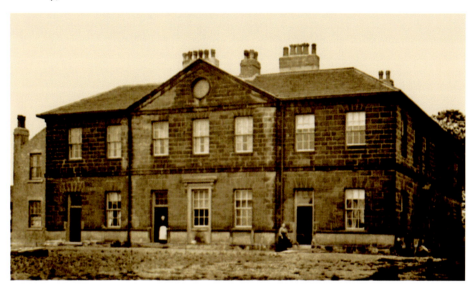

Ackton Hall.

Ackworth Park

Ackworth Park was bought from the Lowther family in 1763 by Sir Francis Sykes. The old house was remodelled, possibly by James Paine, in the 1760s. It was eleven bays by five, with a pediment over the middle three bays of the longer front and a canted bay on the shorter side.

The house passed through various hands, including Alderman Solly, Mr Petyt and John Gully. Gully, born 1783, was the son of a butcher and took up bare-knuckle prize fighting after being imprisoned for debt. After a short but successful career in the ring he made a fortune as a racehorse owner, buying Ackworth with the proceeds in 1832, the year he became MP for Pontefract. According to contemporary doggerel:

> One wonders why Pontefract her name did sully
> By returning to parliament, Gully.
> The etymological reason one supposes
> Is his breaking the bridges of so many noses

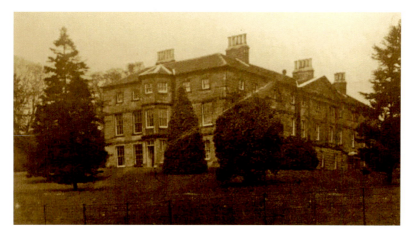

Ackworth Park.

In 1862 he acquired Cocken Hall, County Durham, and its mines and made a further fortune. He sold Ackworth in the 1850s to Henry Hill. Ackworth Park was demolished in the 1950s.

Adwick Hall, Adwick le Street

The Washingtons bought Adwick in 1560 and Richard Washington built the hall in 1673. It remained a Washington seat until it was confiscated by Cromwell's commissioners. Darcy Washington recovered it on payment of a substantial fine. Financial embarrassment forced the sale of Adwick to Sir George Cooke in 1712. In the 1790s the hall was bought by the nabob George Wroughton, who had it

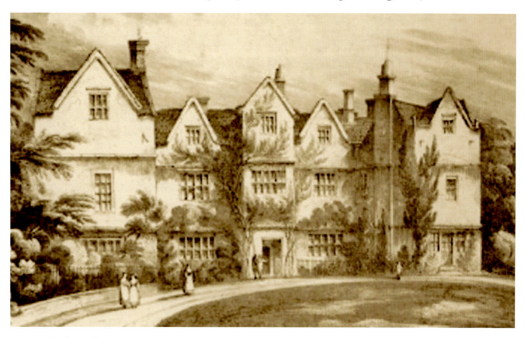

Adwick Hall.

remodelled by William Lindley of Doncaster. Adwick was a ladies' school run by Miss Simpson by 1820, but this closed in 1849. Adwick was in ruins by 1864 and demolished sometime afterwards.

Aldwarke Hall, near Rotherham

The original Aldwarke Hall, a long low range with many gables and an oriel window, dated from the seventeenth century and was the seat of the Foljambes. It was rebuilt around 1720 by Francis Foljambe. The new house was H shaped and of three storeys. A balustraded parapet was added later and the interiors were remodelled by James Wyatt in the mid-1770s. Aldwarke was demolished in 1899 and a steelworks was built on the site.

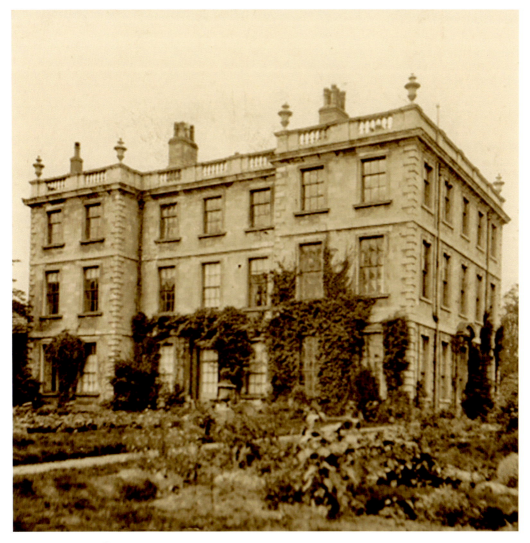

Aldwarke Hall.

Allerton Hall, Bradford
Allerton Hall was built in 1785 and demolished in 1968 after its purchase by Bradford Council. It was built for Joshua Firth and was a relatively small house of three bays and brick with stone quoins. Allerton was later owned by Benjamin Kaye, master clothier, and later still by Sir F. S. Powell.

Alverley Hall
Allverley was built around 1770 by Joseph Dixon who sold the house to Thomas Bradford, who in turn sold it to Brian Darwin Cooke, who enlarged and altered the mansion. Alverley remained the property of the Cookes until it was sold by Revd Charles Cooke. In 1804 the hall was described as 'an agreeable and comfortable residence'. Nineteenth-century tenants included the Cookes, the Egertons from 1885, then the Ellises. By 1903 the hall was available to let unfurnished. The following year the hall and estate were offered for sale by auction, but were withdrawn when the bidding only reached £4,000. Mr and Mrs Reginald Thompson, their family and five servants were living at Alverley Hall at the time of the 1911 census. In 1919 the hall became a residential training centre for young women. When this closed in 1926 it was divided into flats, initially to house miners (and their families) who worked at Yorkshire Main Colliery. During the Second World War, the hall and estate were used as a training area by ARP personnel. The hall then fell into disrepair and the remains were demolished.

Alverthorpe Hall, Wakefield
The Maude family acquired Alverthorpe in the early seventeenth century. Originally built in 1585, the house was rebuilt around 1700 for Daniel Maude.

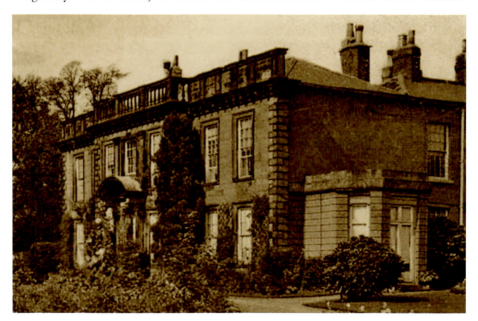

Alverthorpe Hall.

In 1754 Thomas Maude sold the estate to his cousin, Revd William Lowther, whose son became 1st Earl of Lonsdale. In 1800 Alverthorpe was sold to the Wakefield solicitor Benjamin Clarkson. When Clarkson died in 1820, his widow and two surviving daughters moved away and the hall was let. In 1837, tenants included Frances Maude, a descendant of the hall's former owners. On her death in 1842, the hall was let to George Sanders, a Wakefield corn merchant who later served as the city's MP. In 1855 the hall became a boys' boarding school run by George Laurence. The school closed in 1857 when Laurence went bankrupt. Henry Clarkson (Benjamin's nephew) moved to Alverthorpe Hall in 1864. Henry was a noted historian and author of *Memories of Merry Wakefield*. The last occupants were the sisters Louise and Christabel Clarkson. The hall was demolished in 1946 by the local council and a school was built on the site.

Local legend has it that a boggart or padfoot (a white creature the size of a calf and with glaring eyes) would appear from a well on the estate and parade under the garden wall, dragging its clanking chains.

Alwoodley Old Hall, Leeds

Alwoodley Old Hall was originally the seat of the Franks. It was bought by Sir Gervase Clifton in 1630 and sold to Cornelius Clarke thirty years later. It was sold again in 1729, to 1st Lord Bingley, from whom it passed to the Lane Fox family of Bramham Park. It remained in their hands until its demolition in 1969, the result of a decision to build a new reservoir for Leeds.

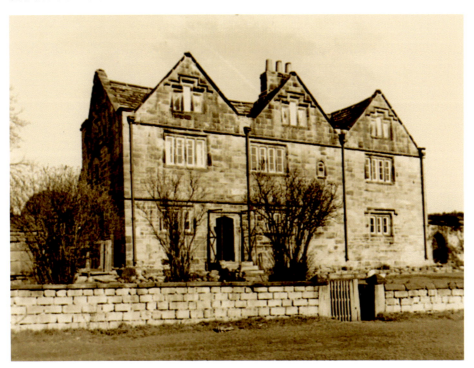

Alwoodley Old Hall.

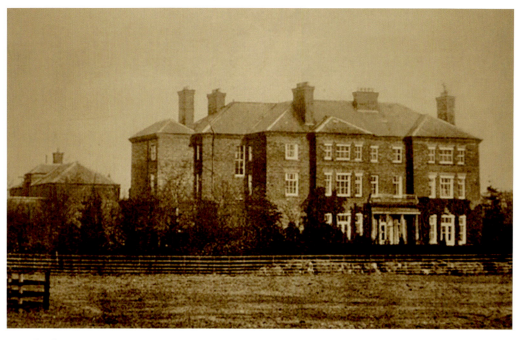

Appleton House.

Appleton House, Nun Appleton
Appleton House, which had something of the appearance of a hall of residence, probably dated from around the time Lord Holden bought the estate from the Milner family. The house, which was built of red brick, was sold again in 1913 and demolished after the Second World War.

Austhorpe Lodge, Whitkirk
Now demolished, Austhorpe Lodge was the birthplace of John Smeaton, builder of a lighthouse on the Eddystone Rock. Smeaton is buried in Whitkirk Church. The Austhorpe Lodge estate was bought by the Ingrams of Temple Newsham who broke it up, adding parts to their own property.

Badsworth Hall, Badsworth
During the Civil War, Badsworth was confiscated by Parliament from the Dolman family. In 1653 Sir John Bright bought the estate which would remain the seat of the Brights until the eighteenth century. After the marriage in 1752 of Mary Bright, heiress of Thomas Bright, to the Marquess of Rockingham, the house, which dated from the late seventeenth and early eighteenth centuries, was most often tenanted. John Carr made alterations for the 2nd Marquess of Rockingham around 1780. The house was later a sporting base for the 1st Duke of Cleveland. In the 1850s it was purchased by Richard Heywood Jones. The estate was sold again on the death of his widow in 1926. Major Holliday lived in the hall before moving to Copgrove Hall in 1936. Derelict by 1965, it was subsequently demolished. The stables were converted into a house.

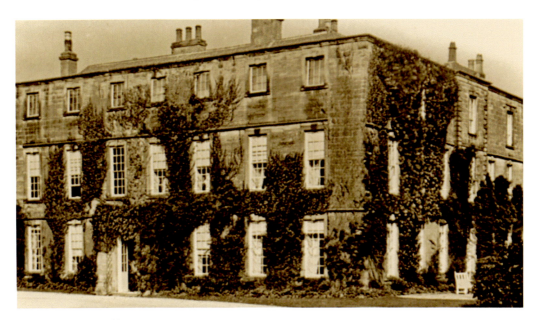

Badsworth Hall.

Barnbow Hall, Barnbow

In medieval times Barnbow was the seat of the (de) Grenefeld family and their descendants, who held it from 1290 to 1568 when John Newcomen, grandson of John Grenefeld, sold the estate to his wife's brother, Richard Gascoigne. The Gascoignes of Barnbow were a branch of the Gascoignes of Gawthorpe, Harewood, and were noted recusants. Barnbow was allegedly the scene in 1680 of a plot by Sir Thomas Gascoigne Bt to overthrow the king and Parliament and return the country to Roman Catholicism. The sole evidence was that of Robert Bolron, steward of the Gascoigne mines. No case was ever effectively made against Sir Thomas, but his nephew, a priest by the name of Thweng, was condemned and executed. Sir Thomas, who defended himself at trial, was said to have pretended to be so deaf that he was unable to hear the evidence put to him. After his acquittal he retired to the monastery of Lamspringe in Germany where his brother was abbot. Fifty years later workmen digging in a York churchyard found a coffin bearing a copper plate with a Latin inscription referring to a priest condemned 'for the supposed plot of 1680'. The Barnbow estate remained in the Gascoigne family until the twentieth century, but they moved to Parlington in the early eighteenth century and Barnbow was demolished in 1721.

Barnburgh Grange, near Doncaster

For 300 years before the Dissolution, Barnburgh Grange belonged to Nostell Priory. At the Dissolution it passed to Francis Shepherd. Thomas Vincent (d. 1667) bought the Grange and his descendants owned it for around a hundred years. It was then sold to James Farrer. In its final form it was a large plain house of three storeys with irregular fenestration and a plain classical doorcase. The house was

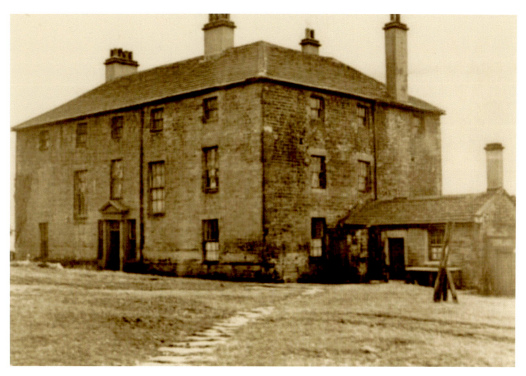

Barnburgh Grange.

bought by Mexborough Urban District Council in 1928 for use as a farmhouse and demolished in 1965.

Barnburgh Hall, Doncaster

Barnburgh was an Elizabethan house altered in the eighteenth century. John More, son of Sir Thomas, acquired the house through marriage with Anne Cresacre, whose family had owned Barnburgh since at least the thirteenth century. Sir Thomas More is believed to have been a regular visitor to the estate. The Cresacres had earlier transformed their manor house into a more comfortable mansion, built around three sides of a courtyard. During the sixteenth century the house, then the home of Sir Thomas' grandson, also Thomas, was a refuge for Roman Catholic priests and contained a number of specially constructed hiding places. The house was allegedly haunted by a ghost who walked a hidden tunnel from the house to the ruins of a chapel in the grounds. The house was altered in the eighteenth century when the original panelling was removed and replaced and modern fireplaces were introduced. Further alterations, including to the windows, were made in the nineteenth century.

Barnburgh Hall remained in the More family until the death of Thomas Peter More, the last of the family, in the early nineteenth century. Henrietta Griffith lived at the hall until 1835 when the property was leased to the Hartop family, who lived there until 1911, although the house was sold to the Montagus in 1859. In 1897

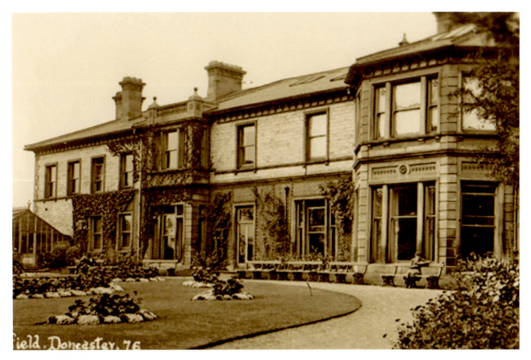

Beechfield House.

John Hartop lived at Barnburgh and in 1922 the owner was F. J. O. Montague, with Frederick Dundas as tenant. Barnburgh was bought by the National Coal Board in 1947 and demolished due to mining subsidence in 1967.

Beechfield House, Doncaster

When it was built around 1812 by Henry Preston, Beechfield stood in a rural location, although it was later swallowed up by urban development. In 1829 the owner of Beechfield was Revd William Cuthbert, who ran it as a private school. The next owner was William Henry Foreman, who extended it and leased it to a variety of tenants, including Sir Isaac Morley, director of the Sheffield & Rotherham Railway, and Richard Morris, who transformed the grounds, frequently opening them to the public. When Richard Morris's widow died in 1907, the trustees of the Foreman estate offered the property to Doncaster Corporation, which bought it for £12,500. The house opened as an art gallery in 1908 and functioned as such until it was demolished in 1963 and a technical college was built on the site. Beechfield was a long, undistinguished, vaguely Italianate building with a massive bay window at one end of the principal front.

Belle Vue House, Sheffield

Built in the eighteenth century, Belle Vue was at one time home to the Duke of Norfolk's colliery agent, John Curr. It was the birthplace of Edward Curr, secretary to the Van Diemen's Company. Belle View House was later demolished.

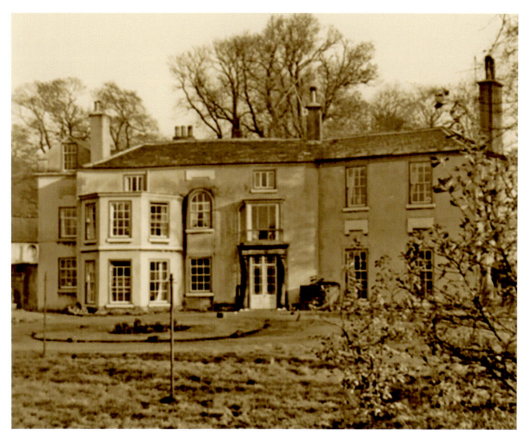

Belle Vue House.

Bewerley Hall, Pateley Bridge
Originally a property of Fountains Abbey, the manor of Bewerley was bought in 1674 by Mary, Lady Yorke, for her son Thomas. John Yorke transformed the house in the last quarter of the eighteenth century, adding round towers and an extension containing a morning room. John Yorke left the estate to his nephew, also John Yorke. The hall was restored and enlarged between 1815 and 1821. Anthony Salvin made alterations in 1832. The house then passed to John's sons, John and Thomas, with Thomas modernising the hall. Thomas was succeeded by his grandson John Yorke (1904–96) whose mother sold the estate after the First World War. The house was demolished in 1923 and the estate, once of 15,000 acres, split up. Yorke's Folly, two rustic pillars on the nearby moorside looking like the piers of an ecclesiastical nave, was built for John Yorke by local unemployed workmen; a third pillar collapsed in 1893.

Bewerley Hall.

Bierley Hall, Bradford

Bierley Hall, which stood near the site of the Bradford Hospitals, was the seat of the Richardson family. Built in the 1630s and remodelled in 1676, it had a centre with four round gables, each with a round window, the parapet crowned with urns, as well as wings with conventional gables. The house was remodelled again about 1750 when an attic storey and a huge pediment with a semicircular (Diocletian) window were added.

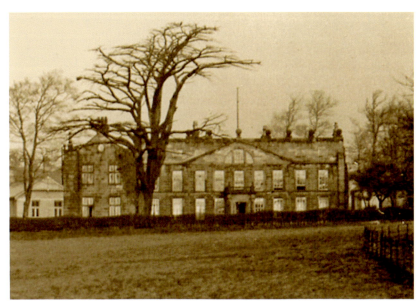

Bierley Hall.

At the end of the eighteenth century extraction of coal and ironstone began on the estate and the house was tenanted. In the nineteenth century the house was owned by a Miss Currer of Eshton Hall, but by the end of it had been bought by Bradford Council for use as an isolation hospital. Bierley was demolished in the late 1960s and the park used for housing.

The grounds created by the Richardsons between 1720 and 1760 included four lakes and the first glasshouse in England. As avid plant collectors, the collection included more than 2,000 species and the first cedars of Lebanon in the country, one of which had been presented to Richard Richardson MD FRS by Sir Hans Sloane. Richardson was an eminent botanist and created an important garden at Bierley, of which fragments remain.

Bilham House, Hickleton

Bilham House was demolished in about 1860. Thomas Selwood remodelled the house and landscaped the grounds in the first half of the eighteenth century, and the property passed by descent to Selwood Hewitt and his sons. During the Hewitt's ownership a belvedere designed by John Rawsthorne was built on the estate. Bilham was bought by the trustees of the famous Thelusson will, model for the Jarndyce case in Dickens' *Bleak House*. In the 1820s the tenant was the 1st Duke of Cleveland. The belvedere survives.

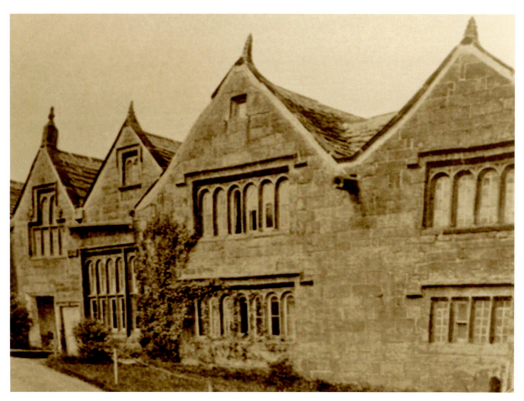

Binroyd Hall.

Binroyd Hall, Halifax

Binroyd was a five-gabled house of ashlar built in the time of Elizabeth I by the Brigg or Briggs family on land once belonging to the Binns. It replaced an earlier hall, part of which was incorporated into the new building. In 1712 the Briggs sold Binroyd to Richard Sterne, Laurence Sterne's uncle. His son passed the hall to the Pulleyn family, who occupied it until the mid-twentieth century. The hall was rebuilt in 1914 by Jackson and Fox of Halifax on a smaller scale, retaining some original features, and is now two houses. Some of the plasterwork, by Michael Wainhouse and dating from 1670, is in Bankfield Museum, Halifax.

Blake Hall, Mirfield

Blake Hall was rebuilt by William Turner in 1747 as a handsome five-bay three-storey brick house with stone dressings. In 1845 Joshua Ingham made additions designed by Ignatius Bonomi.

Blake Hall was the model for Wellwood House in *Agnes Grey* by Anne Brontë, who was governess to Joshua Ingham's children. The Inghams' fortune came from coal, but this gradually failed and Major Joshua Ingham moved out in 1921. The new owner of the estate was Blake Hall Estate Ltd, who sold the land for building. Maurice Avison, a director of the company, occupied the hall from 1931 to 1951. It was demolished in 1954. The hall had a Queen Anne staircase of burled yew which was taken to Long Island, America. A later newspaper article described how the new owner of the staircase reported seeing the ghost of a lady in a full skirt, her hair tied in a bun, ascending the staircase before disappearing; if true, it's a real case of 'the Ghost Goes West'.

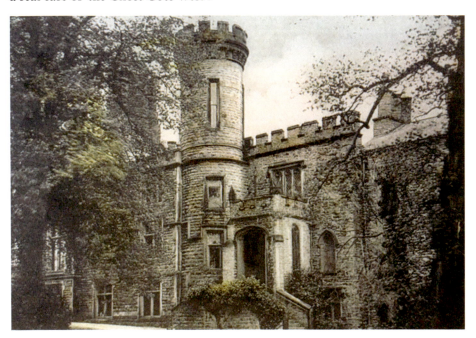

Bolton Hall.

Bolton Hall, Bolton by Bowland

Henry VI sheltered at Bolton Hall after the Battle of Hexham in 1464. The grounds contained King Henry's Well, allegedly discovered by him during his stay, and in the house was King Henry's Room. The hall was the seat of the Pudsey family from the fourteenth century until the line failed in 1771. The core of the hall was ancient, but it was remodelled to the designs of J. M. Gandy for John Bolton after he bought the house in 1808. Bolton sold it around 1830. The house was altered in 1897 when it belonged to Booth Elmsall Wright. By 1922 the hall was unoccupied. After falling into decay, it was demolished in the late 1950s.

Bradford Manor House, Bradford

The Rawsons probably built their original manor house in the reign of Henry VII. They rebuilt it in 1705. A grand three-storey house of red brick, it had a staircase with mural paintings by Parmentier.

The Rawsons became rich through ironworking and bought Nidd Hall, leaving Bradford but retaining the lordship of the manor. The house was next occupied by John Hardy, whose son Gathorne, later 1st Viscount Cranbrook, Secretary

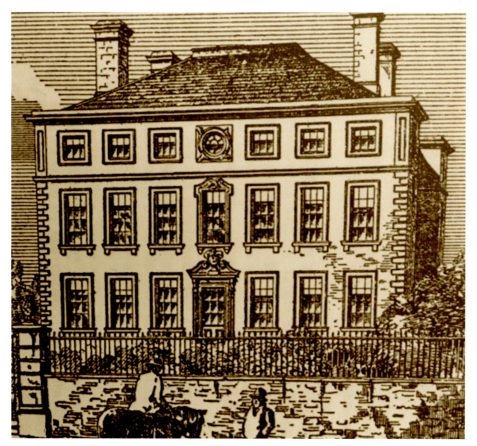

Bradford Manor House.

for India and Home Secretary, was almost certainly born there. By 1824 the area surrounding the house had become a market. The manor house was demolished in the 1860s and a market hall was built on the site. It appears to have been a temperance hotel before its destruction.

Bramhope Hall, Bramhope

The Dyneley family acquired Bramhope in the sixteenth century and the hall, now demolished, dated from the middle of that century. The grounds have been used for a housing development. A circular eighteenth-century gazebo survives, as does a Puritan chapel built by the Dyneleys in 1649.

Broomhall, Wrenthorpe

Broomhall was the ancient seat of the Broom family, who were living there in 1300 according to a manorial survey. In 1566 the hall was the seat of Henry Broom and his wife Elizabeth. In 1569 Stephen Broom was required to provide a coat of mail, a long bow and arrows and a bill in defence of the realm against insurrection in support of Mary, Queen of Scots. By the end of the century Broom Hall had left Broom hands, ending a connection of 300 years. The purchaser was Robert Saville, who left the hall to his son, also Robert, who in turn sold it to John Lowden in 1612 for £400. In later years the hall was principally used as a farmhouse, passing through a number of hands. Broomhall was demolished in the early 1970s. The location is commemorated by Broom Hall Avenue and Crescent.

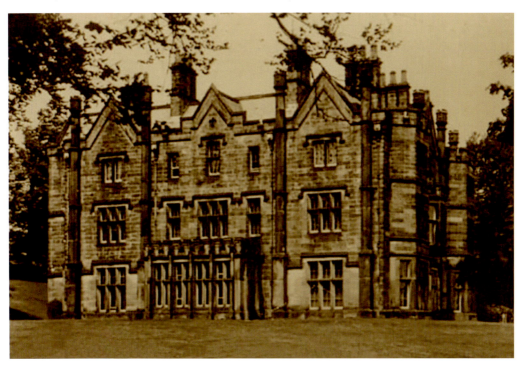

Broomhead Hall.

Broomhead Hall, Penistone

The first Broomhead Hall was built in the fourteenth century and a second by Christopher and Mary Wilson in 1640. The final Broomhead was built in 1831 by James Rimmington and was a huge mock-Tudor mansion with a spectacular hall and a Georgian staircase brought from Kiveton Park. 617 Squadron, the Dambusters, practised on the reservoirs nearby and Wg Cdr Guy Gibson stayed at Broomhead to supervise the bombing practice. After a long period of dereliction, Broomhead was demolished in 1976.

Brotherton Hall (Brotherton House), Brotherton

In the early nineteenth century Brotherton was the home of the Crowder family and later of the Mackenzies. In the late 1940s and early 1950s Brotherton was the residence of Herbert Moorhouse. The property has been built over.

Brushes (The), Firth Park

The Brushes was a dramatic Gothic mansion with an octagonal tower that was supposedly haunted by a grey lady, whose face appeared at one of the windows. The apparition was said to be that of Norah, a maid who killed herself by jumping from the tower after she was found sleeping with the owner by his incensed wife – another version says it was after she was spurned by her gardener lover. The house was originally built by John Booth in the late eighteenth century, but its final appearance was largely Victorian. The Booths had bought the property in 1708 and it remained their seat until they sold it in 1888 to C. W. Kayser, a Sheffield Steel magnate. Kayser demolished the original house and built the castellated mansion. The house had a series of owners before it was sold to Sheffield Corporation in 1919 by Miss Wake. For many years a school, The Brushes has been demolished and Longley College built on the site.

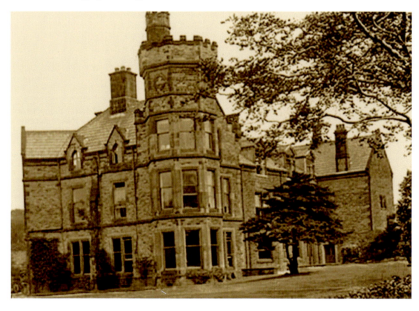

The Brushes.

Byram Park, Ferrybridge

Byram Park was the Yorkshire seat of the Ramsdens, who bought it in 1612 from Sir Marmaduke Constable. With money from rents on property in Huddersfield and the wool trade, the Byrams were able to remodel a large sixteenth-century house (illustrated by Buck), which had been extensively altered in the seventeenth century. The Ramsden of the day, a Royalist, was captured by the Parliamentarian General Fairfax, and in 1648 Cromwell took up residence at 'Byron House near Pomfret'. In about 1770, Sir John Ramsden Bt undertook a modernisation of the house to the designs of John Carr, who unified and extended the structure, transforming it into a much more coherent whole. The alterations included the addition of a seventeen-bay south wing. Robert Adam contributed to the interior and his library was of particular quality. The park was designed by Capability Brown, while the stables and probably the Home Farm, which survive, are by Carr. Towards the end of the nineteenth century the Ramsdens moved their principal seat to Bulstrode Park in Buckinghamshire and Byram Park began its decline. It was sold in 1922 and partially collapsed in the 1930s. The remainder was demolished about 1955.

Caley Hall, Otley

Caley Hall was part of the estate of the Fawkes family and the grounds were used by Walter Ramsden Hawkesworth Fawkes (1769–1825) as a home for his zebra, wild hogs and deer. Turner painted Caley Hall, Yorkshire, in *Stag Hunters Returning Home* in 1818. The hall was demolished in 1964.

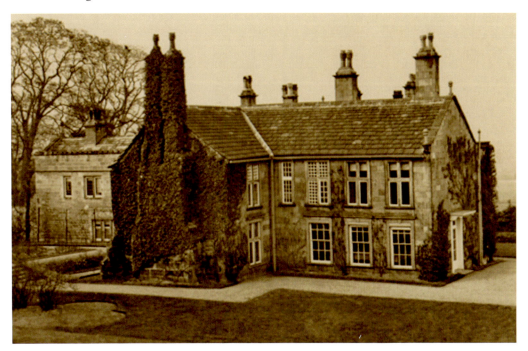

Caley Hall.

Campsall Hall, Campsall

From the early seventeenth century until 1945 Campsall Hall was the seat of the Frank family. The Franks had been seated at Grimsby since the reign of Edward II, acquiring large estates in Yorkshire by marriage and purchase. Richard Frank bought Campsall in 1625. A later Richard Frank (1698–1762) was a noted historian and early fellow of the Society of Antiquaries. The Franks became Bacon-Franks following a marriage to the heiress of Waller Bacon of Earlham, Norfolk. Their son Bacon Frank inherited Campsall in the early 1760s.

John Carr was employed by Bacon Frank (1739–1812) in 1762–64 to remodel Campsall. It was a large, rather unlovely stuccoed house of three storeys with little exterior detailing but two full-height canted bay windows on its shorter side. In 1897 the owner was Frederick Bacon-Frank, who had inherited the estate at the age of five in 1834, and during Frederick's minority the hall was tenanted. After his death in 1911, his widow inherited the estate; there were no children. Mrs Bacon-Frank died in 1942 and was the last of the family to live at Campsall. In 1942 a sale of manuscripts from Campsall raised £3,337 and included a manuscript of Chaucer's *Troilus and Criseyde* as well as letters from Queen Elizabeth I, James I, Sir Walter Raleigh and the Earl of Leicester.

The next heir was Miss Helen Marjorie Walker, Mrs Bacon-Frank's former companion who lived in York until her death in 1971. The National Coal Board developed housing in the park and the house was converted into flats. Despite proposals to turn it into a retirement home, Campsall Hall was demolished in 1986, by which time it was derelict. The stables and lodges were also demolished.

Campsall Hall.

Campsmount, Campsall

Campsall's other house, Campsmount House, was designed by John Carr for Thomas Yarbrough and built in 1752–55. Carr's fee for the designs was 5 guineas. Yarbrough had previously commissioned designs from Howgill, Flitcroft and Paine before settling on Carr, who may have been better value for money. The result was a severe two-and-a-half-storey five-bay house. There was fine plasterwork in the state rooms. Before the building of Campsmount, the Yarboroughs had lived at nearby Brayton Hall. Thomas Yarbrough died in 1772 at the age of eighty-five, leaving two daughters, the last of whom, Elizabeth, died in 1802.

Campsall passed from Elizabeth to her cousin George Cooke of Streetthorpe (later renamed Edenthorpe). Cooke-Yarboroughs continued to live at Campsmount until the 1930s. George Eustace Cooke-Yarbrough was the last of the family to live there before he left in 1930 to live at Wadworth Hall. For a period Campsmount was let to Major Hibbert of the King's Yorkshire Light Infantry. In 1935 West Riding County Council bought the house for potential use as a mental hospital. Following use by the army during the Second World War, the costs of potential restoration were considered too high and the house fell into decay. Following use as a hostel it was demolished in 1959. A school now stands on the site.

Campsmount.

Carlinghow House (Carlinghow Old Hall), Batley
Carlinghow Old Hall was the seat the Eland family in the later Middle Ages. The Old Hall was built by Robert Eland, who died in 1521. A loose date stone on-site was inscribed with the year 1505. By the late 1960s when the hall was recorded in detail before its demolition, all that remained was a two-storey, two-bay timber-framed range with stone walling on the ground floor and diagonal timber 'stud' walling with stone and brick infill on the first floor. An 1894 drawing of the hall suggests that the building was no more extensive then than it was in the 1960s and was presumably only a fragment of a much larger house.

Car (Carr) House, Rotherham
Nothing remains of Car (or Carr) House, which was demolished in 1964. The land on which it stood belonged to Monk Bretton Abbey before the Reformation and afterwards passed through the Rokeby, D'Arcy and Westby families to the Gills. John Gill was High Sheriff of Yorkshire in the 1690s. The Gills later sold the house, which was home to coalmaster William Fenton in 1825. From 1845 it was the residence of James Yates and from 1858 of George Hague, a colliery owner. By 1871 it was the home of the Rhodes family. Before its demolition it had been divided into flats and a gasworks built close by.

Carr House, Doncaster
The Carr House estate was purchased by High Childers in 1604 and he built himself a country house shortly after. Carr House remained the seat of the Childers until 1750 when they moved to Cantley Hall. The Childers leased the vacated Carr estate to a number of tenants, including the Marquess of Granby, until Sarah Walbanke Childers sold it in 1805. The purchaser was a J. Maw, who in turn leased the house to Peter Inchbalds, who used it as a school. In 1884 Carr House was sold to Doncaster Council by R. H. Cooper. For part of the twentieth century Carr House was used as a fever hospital, but following a period of disuse it was burnt down in the early 1930s. The Park Hotel now stands on the site.

Carr House was a five-bay, two-storey house with a higher three-bay extension to one end. There was a pedimented one-bay attic storey over the central entrance of the original block.

Castle Carr, Luddenden Dean
Castle Carr was a huge Gothic Revival pile arranged around a courtyard with a 60-foot-high grand hall. It was built in 1859–72 for Leah Priestley Edwards, son of Sir Henry Edwards of Pye Nest. The architects were Thomas Risling and John Hogg. Edwards sold the house in 1876. The Yorkshire Water Authority built the Deanhead Reservoir behind the house, which was demolished in 1962. The lodge and a ruined gateway survive.

Centre Vale Hall, Todmorden
John Fielden sold the Centre Vale to Todmorden Council in 1912 for use as a public park. The mansion was a hospital during the First World War and was later used as a museum. It was demolished in 1953. The original house was a

square block of five bays with a long staircase hall running front to back. A large extension with canted bay windows was later added at the end of the hall opposite the entrance. The grounds of Centre Vale are now a public park.

Chadwick Hall, Mirfield
Chadwick was a stone house with a hall and cross wings. The gables were timber framed.

Chevet Hall, Wakefield
Chevet Hall, demolished in 1955, was a major house that began life as an early Tudor mansion built by Sir John Neville around 1529 after he married Elizabeth Bosville, heiress to the estate. A beam in the house was inscribed: 'This Hows was mad by John Nevyll and dame Elizabeth his wyfe… 1529.'

The house remained in the Neville family, passing to a collateral line. Revd Cavendish Neville (d. 1749) rebuilt and enlarged the house, adding a Palladian façade that hid awkward planning, evidently the result of a complicated architectural history. After Cavendish Neville's death, the estate passed by marriage to the Pilkingtons of Stanley Hall. Sir Thomas Pilkington (d. 1811) added a new stair hall with a Greek Revival screen to the design of John Rawsthorne.

During the occupancy of Sir Lionel Pilkington (1835–1901) the house was refaced in stone. The last owner was Sir Thomas Milborne-Swinnerton-Pilkington, who sold the hall, by then empty, to Wakefield Corporation in 1949 for potential use as a children's home. The hall was demolished in 1955. The land surrounding the site of the hall is now a country park.

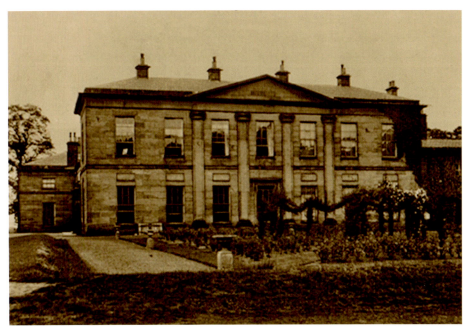

Chevet Hall.

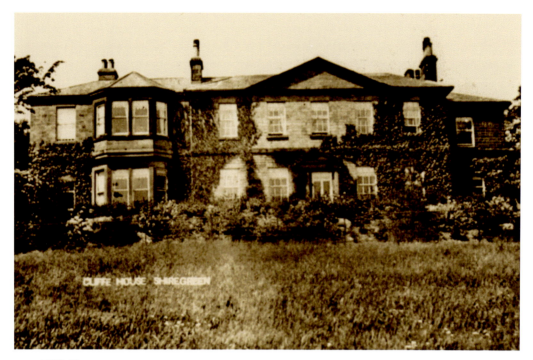

Cliffe House.

Cliffe House, Sheffield

Cliffe House was built for Sarah Booth of The Brushes in the first decade of the nineteenth century. After her death, the house passed to her son but was tenanted. In 1875 Charles Booth sold the house to Francis Smith. Other owners followed. Cliffe House remained a private home until 1927. After a period standing empty, it became the Cliffe Institution for Mental Defectives. Cliffe House, which was also known as Spite Hall, Spitfire Hall and Pilfer Hall, was used as a fire station during the Second World War, then demolished shortly afterwards. A fire station was built on the site.

Conisburgh Old Hall

The Old Hall was originally the administrative centre of priory lands. It was rebuilt shortly after the Reformation. Conisbrough Old Hall was demolished in 1938 as part of a slum-clearance scheme.

Coniston Hall, Coniston Cold

The Coniston Hall estate belonged to the Malhams until 1665, then successively the Coulthursts and the Laycocks. The estate was bought in 1812 by George Garforth, who commissioned George Webster of Kendal to design a new house.

The house was classical with a three-bay pediment on the garden front and a Doric portico on the entrance side. The house passed to the Tottie family and was put in the market after the death of Richard Tottie in 1969. It was demolished in 1972.

Lost Country Houses of South and West Yorkshire

Coniston Cold Hall.

Cragg Hall.

A new stone neo-Georgian house was built in 1972 by Websters of Kendall for Michael Bannister incorporating the portico of the earlier house. The house has landscaped grounds (designed by Lanning Roper) overlooking a lake.

Cragg Hall (New Cragg Hall) Cragg Vale

Cragg Hall was the home of the Hinchliffe family, whose fortune came from cotton spinning. It sported a mixture of Dutch gables, oriel and bay windows. Cragg Hall was gutted in a fire in 1921. Following the fire, the Simpson-Hinchliffes moved to Wetherby Grange and the Cragg Hall estate was sold.

The unusual gatehouse survives, like the hall designed by Edgar Wood and built 1904–05 for William Algernon Simpson-Hinchliffe. At the age of twenty-two William Algernon married the forty-nine-year-old Helen Hinchliffe, heir of the millowner Hinchliffe Hinchliffe. In the words of a local historian, Mrs Simpson Hinchcliffe 'was stricken with nymphomania and bought the treatment!'

Crofton Castle, near Wakefield

Crofton Castle was a Gothic house built in 1853 by John Blackburn. During the Second World War the castle accommodated Italian prisoners of war. The house was then bought by the Abbott family who allowed it to fall into disrepair. Crofton Castle was repeatedly associated with reports of hauntings and paranormal activity. In 2004 the house suffered a serious fire, after which it was demolished. Before its demolition many witnesses reported seeing a white figure known locally as the 'Grey Lady' at a rear window. New housing occupies the site, although the developers hedged their bets by ensuring that no house was built on the precise site of the mansion, which is instead covered by a road.

Crofton Hall, Wakefield

Crofton Hall was built by Joshua Wilson in about 1750. The Wilson family were often absent and the hall was tenanted. At one time the hall was let to a school, at which Miss Rachmal Mangaal was first a pupil and then a teacher. She wrote *Historical and Miscellaneous Questions for the Use of Young People*, a popular educational textbook of the time. Elizabeth and Maria Brontë, sisters of the famous authors, were pupils at Crofton Hall School and Charlotte's copy of Mangaal's book is on display in Howarth parsonage.

In 1884 H. S. L. Wilson demolished the original wings and replaced them with larger ones; he also altered the main block in a Victorian style. Lieutenant-Colonel H. L. B. Wilson sold the property in 1935 to George Benton who began to break up the estate. Following military use during the Second World War, the hall became part of a school before being demolished in 1981.

Crookhill, Conisborough

Crookhill was the seat of the Woodyeare family and dated from the mid-eighteenth century. The house has been ascribed to James Paine. When Revd John Woodyeare died childless in 1880 he left his wife Emily life tenancy of the hall. On her death in 1919 the estate of 90 acres passed to Lawrence Woodyeare Blomfield, who tried unsuccessfully to sell it for £3,750. Joseph Humble, a local colliery owner

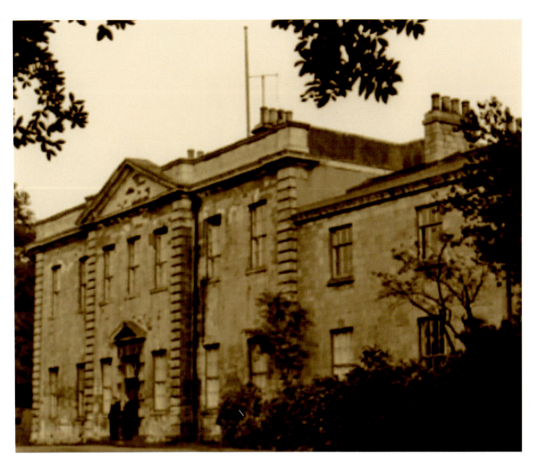

Crookhill.

was tenant of the hall in the 1920s before Lawrence and his son John sold it, in 1926, to West Riding Council. The house later became a TB hospital but closed in 1963. The house was vandalised whilst empty and was burnt out in 1967. The grounds are now a golf course, and the clubhouse stands on the site of the original mansion. The poet Ted Hughes spent time as a schoolboy with his friend John Wholey, whose father was a gardener at Crookhill from 1927.

Crow Nest, Halifax

The first reference to Crow Nest is from 1592. In 1778 William Walker, a wealthy worsted manufacturer, commissioned Thomas Bradley to produce a near copy of Pye Nest, which had been designed in 1767 by John Carr for John Edwards. The two houses had almost identical exteriors, although there were differences of detail in the quadrants connecting the main house to the pavilions, and the Crow Nest pavilions were four bays by three while the Pye Nest pavilions were three bays by three.

The Walker family resided at Crow Nest for approaching 200 years. The house was the home of Ann Walker, who solemnised her relationship with Anne Lister

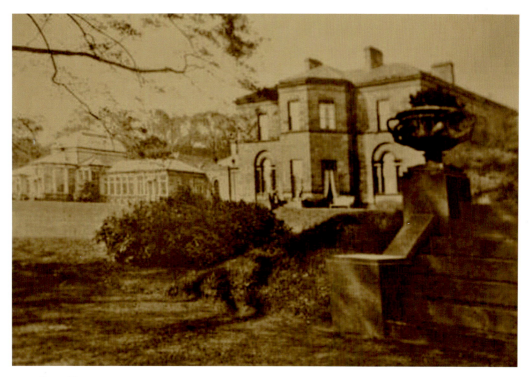

Crow Nest.

of Shibden in York in 1834. Sir Titus Salt rented the house from 1844 to 1858 but was asked to leave after the death of Ann Walker because her brother, Mr Sutherland-Walker, wanted to take up residence. During Salt's first tenure, alpacas, the foundation of his fortune, grazed the grounds. Salt lived at Methley Hall until 1867 when he was able to buy Crow Nest from Surtherland-Walker for £26,000.

During his second period at Crow Nest, Salt created the boating lake and island. Sir Titus lived at Crow Nest until his death there on 29 December 1876. After Salt's death his executors sold the estate to Richard Kershaw, another local mill owner. Crow Nest changed hands several times before Richard Harrison bought the property. During the Second World War, Italian prisoners of war were housed at Crow Nest. The house was never reoccupied and, having fallen into ruin, was later demolished. The grounds are now a golf club.

Crowder House, Longley

Crowder House (also known as Winksley House) was mentioned in deeds of 1402 when Julyan Wilkinson owned the house and estate and passed it to her son Henry. The estate passed through the direct male line until 1722 when Mary Wilkinson, heiress to the property, married John Mellor. In 1859 her descendants sold it to the Wake family and it was restored and developed by Bernard Wake. After the death of Wake's foxhunting-mad daughter Jane ('owd Jane' in local vernacular) the house belonged to John Baker. Crowder House was sold to Sheffield Council and demolished in 1937. Its site is now occupied by housing.

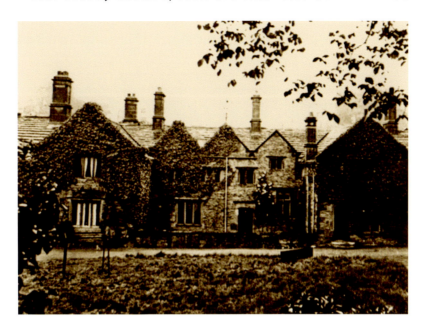

Crowder House.

Darnall Hall, Darnall

Darnall Hall was built in 1723 on the site of an earlier house by Samuel Staniforth (1698–1748) as a residence for himself and his wife. In the second half of the nineteenth century the hall was used as an asylum. At a later date it was reduced to two floors. In the twentieth century the hall housed the Darnall Liberal Club

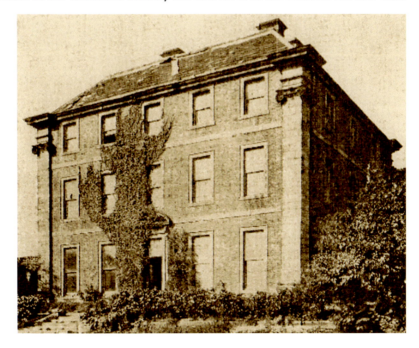

Darnall Hall.

and Institute before being completely destroyed in a fire in April 2010. The house bore an inscription, reading:

> This house was built as you may see
> In seventeen hundred twenty three
> This house was built as you may hear
> By Samuel Staniforth in one year.

Darnall Old Hall, Darnall

Darnall Old Hall was probably sixteenth century in origin. It was also known as 'Dunkirk' after the small square on which it stood. A stone over the door was inscribed 'WBA 1702' for William Bamforth and his wife who were the owners of the hall. The Bamforths acquired the Old Hall from Joseph Walker, who was executor to his brother William. According to local legend William was Charles I's executioner, but unfortunately there is no evidence to support this. By 1726 Bamforth had sold the hall to Marmaduke Carver of Chesterfield, who in turn sold it to Joshua Jepson, in whose family it remained into the nineteenth century. A Mr Hardcastle bought it in the 1820s. The hall eventually fell into disrepair and was demolished.

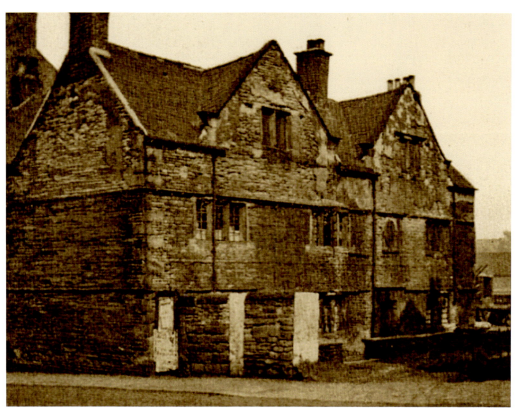

Darnall Old Hall.

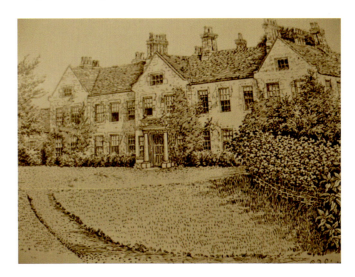

Darrington Hall.

Darrington Hall, Pontefract

After the Norman Conquest Darrington and Stapleton were granted to Ilbert de Lacy. In 1400 the lands belonged to William FitzWilliam, eight generations in descent from Ablreda de Lacy, last of her family. The FitzWilliams probably built the first hall on the present site. In 1518 William FitzWilliam left Darrington to Elizabeth Saville, whose descendants owned the manor until the mid-seventeenth century. In 1671 the estate passed by marriage to the earls of Cardigan, who sold it to Robert Frank, whose daughter married Samuel Saville. Darrington passed by marriage from the Savilles to the Sotherans in 1751 and then to the Sotheran-Estcourts. The Sotheron-Estcourts preferred to live on their Gloucester estates but owned Darrington until around the First World War. In 1919 Lady Katherine Pilkington made the house a hospital for ex-servicemen.

Darrington had two wings: one of the seventeenth century, the other of the nineteenth. The seventeenth-century wing was demolished in the 1980s, while the newer wing survives.

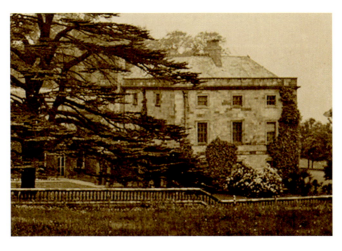

Denby Grange.

Denby Grange, Flockton

Denby Grange was the seat of the Kaye family from the sixteenth century, when it was bought by Arthur Kaye, to the twentieth, when it was sold. A new mansion was built in the eighteenth century, probably by Sir John Lister Kaye (1725–89). In 1948 Sir Kenneth Lister Kaye bought an estate in Ireland and the following year he sold the house and its estate. Denby Grange was demolished in 1950.

Dodworth Hall, near Barnsley

The older part of Dodworth was a classical house of five bays with a small pediment over the central bay, dating from around 1800. Taller wings, which were almost but not quite symmetrical, were added on either side. The house was empty by the end of the nineteenth century and was later demolished.

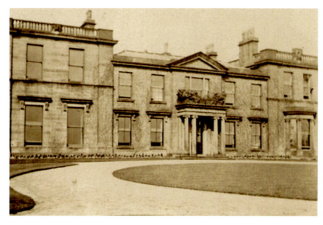
Dodworth Hall.

Dunscroft Abbey

There was never a religious establishment at Dunscroft, which was a grange of Roche Abbey. The house was whitewashed and built to an E plan with wings and a projecting central porch. Duncroft Abbey was demolished around 1966.

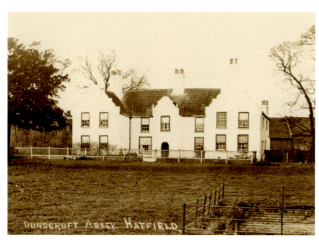
Dunscroft Abbey.

Easthorpe Villa, Mirfield

Easthorpe Villa was built by the Hurst family of maltsters. In 1887 they sold the house to Frank Burnley. Following his death in 1890 Easthorpe was occupied by Fred Jackson Crowther, who was a maltster like the Hursts. In the 1940s Maurice Dew leased the house and in 1953 he bought it, changing its name to Springfield. The house was demolished in the 1960s and the site is now occupied by the Springfield Park housing estate.

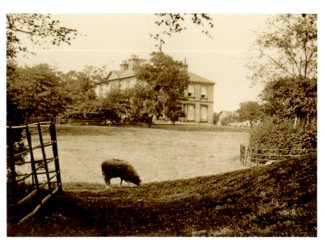

Easthorpe Villa.

Eastwood House, Rotherham

Eastwood was designed by John Carr in the late 1780s for Joseph Walker, whose son Samuel was a friend of William Wilberforce. Joseph was the second son of the ironmaster Samuel Walker. The house had a canted bay and a pediment over the entrance – standard Carr fare. Eastwood had a number of owners during the nineteenth century. The house was sold in 1920 and the grounds used for house building. Demolition followed in 1928 and a new house, which is now a care home, was built on the site.

Eastwood House.

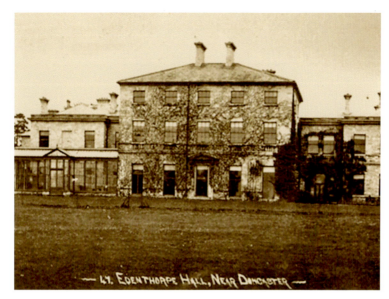

Edenthorpe Hall.

Edenthorpe, Kirk Sandall

In the early seventeenth century, Edenthorpe, then known as Streetthorpe, was the property of the Swyft family. The Swyfts died out in 1635 and the estate was sold to Daniel Baker, a London banker. The 2,000-acre estate was bought by George Cooke of Wheatley in 1769. Cooke built a tall three-storey, five-bay house on the site, possibly to the design of John Carr.

Towards the end of the nineteenth century the estate was owned by Lord Auckland, to whom it had passed by descent from Cooke. Auckland gave it his family name (Eden) and enlarged the house, but sold it in 1897 whereupon the estate was broken up. In 1908 the largest part belonged to Lord Fitzwilliam. Between 1918 and 1920 the hall was occupied by Lord and Lady Moncreiffe before it was put up for sale. In 1922 the central (original) block was gutted by fire and later demolished. The surviving wings were used for a number of purposes including domestic occupation and as a school. The estate was used for building.

Edlington Hall, Edlington

Little is known about Edlington Hall, which stood in old Edlington. It was drawn by Samuel Buck and appears to have consisted of a cross wing (with a central, but not projecting, porch) and projecting gabled wings at either end. A projection, possibly containing a staircase, stood at the junction of the cross wing with one of the projections. The house was probably built by Sir Edward Stanhope Bt, but has long since been demolished.

Elmsall Lodge, North Elmsall

Elmsall lodge was a small mid-eighteenth-century villa built for Fane Cholmley. It had three bays with canted bay windows (each three storeys high) on the garden front. The house has been demolished but the stable block and lodge survive.

Ewood Hall, Mytholmroyd

Originally a seat of the Okes family, in 1471 the Ewood estate was conveyed by its owner Edmund Pylkington to Henry Farrer or Ferror. Henry and his brothers gave land for the building of Heath Grammar School before Henry was murdered in London.

In 1798 Dr John Fawcett and his two sons moved to Ewood from Upper Brearley Hall to open a school for Baptist ministers, which survived until 1835.

Next to the front door of Ewood Hall was a stone with the date '1656' and the initials 'JML', possibly for John Lockwood. Ewood was demolished in the 1970s but the stables survive.

Farm (The), Sheffield

The dukes of Norfolk owned large areas of the land on which Sheffield developed. The Farm was a substantial house adapted from a farm for the 14th Duke and designed by local architects Weightman, Hadfield and Goldie for the duke's occasional visits. It was built in the late 1850s. The house was Tudor in style with a prominent tower. A railway tunnel was built under the garden in 1869 and the house was sold to the Midland Railway in 1869. It was demolished in 1967.

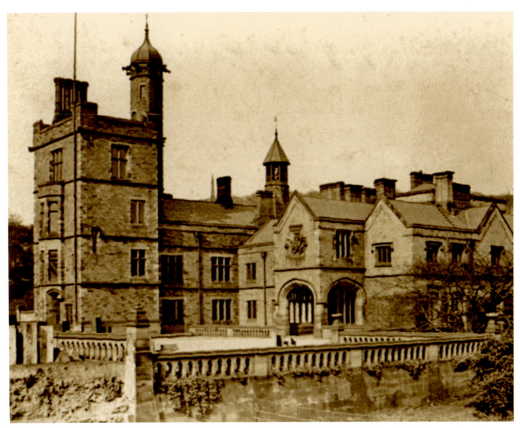

The Farm.

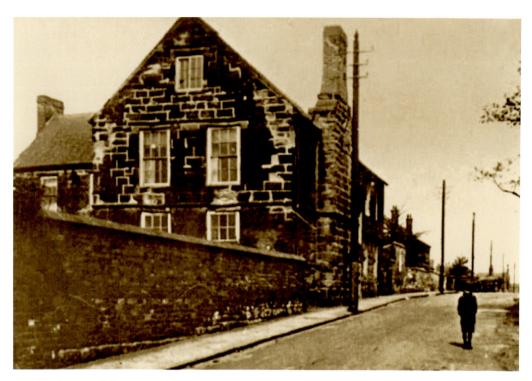

Featherstone Manor.

Featherstone Manor, Pontefract

Featherstone Manor was the seat of the Hippon Family, hereditary gamekeepers of Pontefract Park until the reign of Queen Elizabeth I. In 1857 the manor was occupied by a farmer called John Lake, then in 1865 by George Bradley and after that by William Gower, who ran it as a school. The Denbeigh family lived at the manor house until the 1920s. The property was bought by the council for housing in 1951 and demolished in the early 1960s.

Ferniehurst, Baildon

Ferniehurst was built by Edward Salt, third son of Sir Titus Salt Bt, in the 1860s. Salt lost the house when the family mills went bankrupt in 1892. The house was put on the market the following year but failed to sell until 1896 when it was bought by George Waud, who owned a mohair and alpaca spinners. Waud sold the property in the early 1930s to a quarrying company and the house was demolished. Earlier offers to sell the estate to the local council at a reduced rate had been declined the grounds became a public park.

Fieldhead House, Sheffield

Fieldhead was a rather rambling, mainly Victorian house, built in several phases with a rather strange tower with a pepper-pot top. Charles Dickens visited Fieldhead House in 1858. Fieldhead has been demolished and housing built on the site.

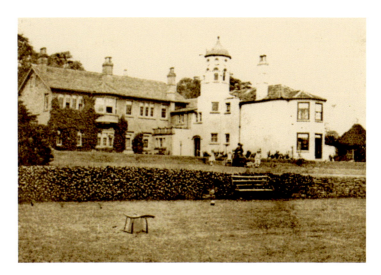

Fieldhead House.

Finningley Park, Austerfield

The name of Finningley is now associated with the well-known RAF base, but it was originally the seat of the Harvey family. In 1897 the owner was John Spofforth Lister, who died in 1903, when the house and 2,400-acre estate were sold. The Parker Rhodes family owned the property until 1943 when it was again sold. The estate was requisitioned during the Second World War, after which sand and gravel were extracted from the environs of the house, which was demolished soon after. Finningley airfield now covers the site.

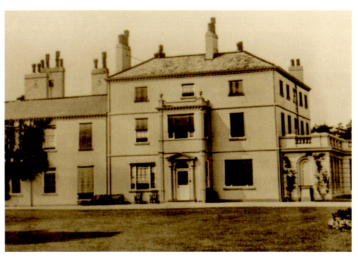

Finningley Hall.

Flasby Hall, Skipton

George Webster of Kendal designed Flasby Hall as an Italianate villa with a tower. It was built between 1843 and 1844 for Cooper Preston. In 1922 the house was owned by John Henry Preston but lived in by Thomas Howarth. The house was later vandalised. A smaller house has been built on the site.

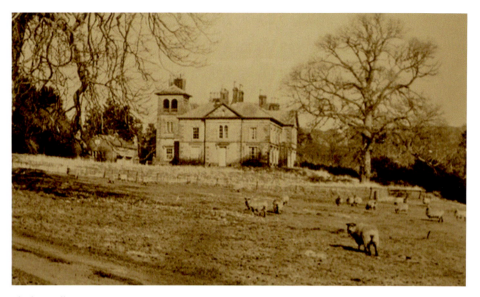

Flasby Hall.

Fryston Hall, Castleford

Fryston Hall originally belonged to the Crowle family. Richard Slater Milnes MP bought it in 1788. It was probably Milnes who added the rather pompous classical wing of seven bays with pilasters and a three-bay pediment. Richard Monckton Milnes, 1st Baron Houghton, was an MP, writer, poet and unsuccessful suitor of Florence Nightingale. The Milnes were later created earls and marquesses of Crewe. The new wing was destroyed by fire in 1876 but subsequently rebuilt. The house was sold before the First World War (the auction catalogue is dated 1904) for use as a mental hospital but never used as one. It was dismantled in 1934. Some of the materials were used to build the Church of the Holy Cross in Airedale. The site is now part of the Ferrybridge Power Station complex.

Gawber Hall, near Barnsley

An ancient manor house and once a seat of the Thorp and Tate families. Paul Tate succeeded his uncle William Thorpe, who died in 1774. The Tates were a noted family of professional artists. Gawber was demolished in 1935.

Gawthorpe Hall, Harewood

Gawthorpe Hall was the successor to Harewood Castle, built by the Aldburgh family in the fourteenth century. For many years a seat of the Gascoignes, Gawthorpe passed to the Wentworths, who made significant additions and alterations in the early seventeenth century. Lord Chief Justice Gascoigne, who died in 1419, appears in *Henry IV* Part II and, with other family members, is buried in the nearby church. After the execution of Thomas Wentworth, 1st Earl of Strafford, his son sold Gawthorpe in 1656. The hall and estate were later bought by Henry Lascelles, and it was his son Edwin who began Harewood House in 1759 and demolished Gawthorpe in 1771. The ruins of Harewood Castle still

stand, dominating the road from Harrogate to Leeds as it turns and rises toward Harewood village. Gawthorpe Church contains an important series of memorials to the owners of Gawthorpe Hall and Harewood House.

Goddard Hall, Sheffield
Goddard Hall is now part of Northern General Hospital. It was built in the early nineteenth century and altered later in that century and in the mid-twentieth century. Goddard is currently boarded up and disused.

Gouthwaite Hall, Nidderdale
Gouthwaite was the seat of the Yorkes from the sixteenth century. A Tudor-style building, it was divided into smaller houses and tenanted during the nineteenth century. Some of its features were transferred to a new house built for the Yorkes on higher ground in a very convincing pastiche of a seventeenth-century West Riding manor house when the original site was flooded under Gouthwaite Reservoir. How much of the old house was preserved is unclear.

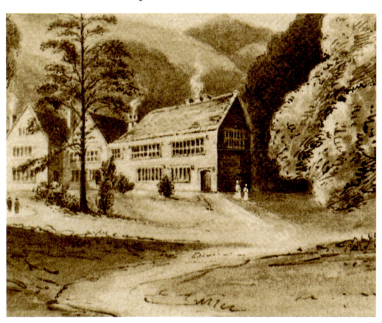

Gouthwaite Hall.

Great Houghton Hall, near Darfield
Great Houghton was built in the reign of Elizabeth I by Francis Rodes for his fourth son, Sir Godfrey Rodes. During the Civil War the hall was attacked and plundered by Royalists. Sir Edward's wife was 'uncivilly treated'. Some of his servants were wounded and one was slain. It remained the seat of the Rodes family until the death of Mrs Mary Rodes in 1789. It was bought by Richard Slater Milnes, who modernised the interior but let it to tenants and moved to Fryston Hall. By 1828 Great Houghton was a public house. It was destroyed by fire in 1960 and demolished.

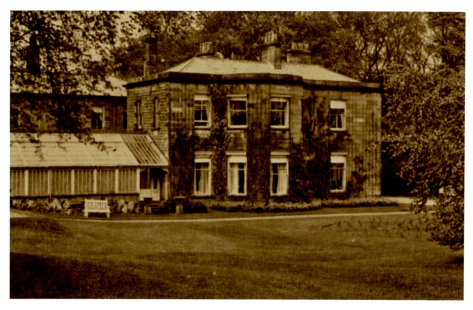

Greenholme Villa.

Greenholme Villa, Burley in Wharfedale

Originally the home of the Whittaker family, Greenholme Villa was rebuilt in a classical style in 1820 and bought by William Fison, a worsted manufacturer, in 1850. It passed to Fison's son but was later let. Greenholme Villa was demolished in 1922–23.

Grimethorpe Hall

Grimethorpe is Yorkshire's most important house whose survival is in doubt. It was built in 1670 for Robert Seaton. The north front is stone, the rest brick with stone dressings. The ceiling of the entrance hall was supported by Doric columns. Robert Seaton died in 1716 and the hall passed to his son, Richard. In 1770 Grimethorpe Hall became the property of a Mr Bayldon of York, who left it to Richard Strangeways. In 1839 his widow sold the hall to Richard Crookes, a surgeon and apothecary from Barnsley. On Crookes' death a trust was set up to manage his estate, which remained in the Crookes family until Captain Arthur Dillon Farrer Crookes sold it to Carleton Main Colliery Company in the 1920s. A long period of decay began and applications to demolish the hall were made on several occasions and refused. Attempts to convert the hall into a restaurant failed and the future of the building remains unclear.

Hagstocks, Shibden Dale, near Halifax

The first reference to Hagstocks dates from the early fifteenth century when, in 1413, William Stancliff left his property at Hagstocks to his son Henry. Hagstocks remained in the Stancliffe family until at least the seventeenth century. The house was rebuilt in the mid-seventeenth century and later used as a farmhouse before being abandoned due to its remoteness and lack of easy access.

Hagstocks.

Hague Hall, South Kirkby

Hague was a late sixteenth-century house built by Matthew Trigott on the site of an earlier manor house. Owned by the Allotts in the eighteenth century, the hall was restored in 1892 but was again empty by 1897. It was subsequently demolished after falling into increasing disrepair.

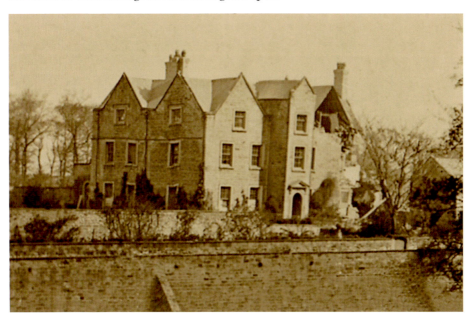

Hague Hall.

Hallam Gate, Sheffield

Hallam Gate was built for Francis Hoole, who lived there in 1790 and probably earlier. Later occupants included Peter Frith, a Sheffield optician, from 1839 to 1844; Charles Hoole, grocer and tea dealer, from 1846 to 1879; and his son-in-law Arthur Wightman, the last private owner, until 1924. The wireless manufacturer G. Graves Ltd used the house from 1929 to 1948 as Hallamgate Works, before selling it to Plessey Ltd. The site was bought by Sheffield Hallam University in 1963 and the house demolished to make way for student halls of residence. The garden and ha-ha survive.

Hallam Gate.

Harrowins, Queensbury

Harrowins was a Tudorbethan house with a dramatic Gothic conservatory built in the mid-nineteenth century for William Foster, managing director of Foster's Mill. Foster later inherited Hornby Castle, Lancashire. Harrowins was inherited by Foster's second son, Robert, who died in 1925. Robert Foster bought the more suitably positioned Park, near Knaresborough, which became his home and Harrowins was demolished.

Harrowins.

Haselden Hall, Wakefield
Haselden Hall stood in the centre of Wakefield and was originally built in the fourteenth century by a wealthy banker who gave it his name. In 1573 the house was bought by George Savile of Thornhill. Savile was a prominent supporter of the protestant settlement of Elizabeth I and a generous local benefactor, founding Queen Elizabeth's Grammar School, Wakefield. At home he added a fine plaster ceiling to the great hall and inserted new panelling and a new fireplace into the chamber next to the hall. The house originally stood round four sides of a courtyard, although all but one range had been demolished by the twentieth century. There were said to be hiding places behind Sir George's new chimney and in the north-west corner of the house on the first floor. A set of stone steps led to a blocked arch under the courtyard, which was said, inevitably, to lead to a tunnel. In this case, however, it is possibly a genuine one, connecting the family rooms with the service quarters on the other side of the courtyard. Sadly, the surviving wing of Haselden was demolished in the 1950s as part of the regeneration of Wakefield city centre.

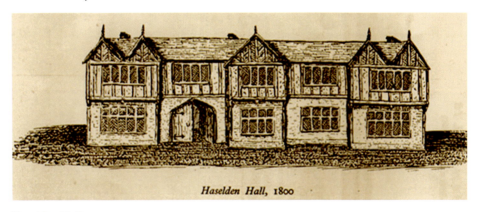

Haselden Hall.

Hassell Hall, Ossett
Dating from the mid-seventeenth century, Hassell Hall was a seat of the Foster family until it was acquired by the wool merchant Robert Dennison in 1758. It was sold to Joshua Thornes in 1768, becoming known as Gren House, and was rebuilt in the nineteenth century. Later the property of the Harrop family, the house was purchased by Ossett Council and demolished in 1961. The site is now a public park.

Hatfield House, near Doncaster
The house that was given a brick Palladian front in the mid-eighteenth century dated to at least the mid-seventeenth century. In the 1640s the Parliamentarian John Hatfield lived at Hatfield. The house had many later owners, including Lord Moncrieff, who moved to Hatfield House after the fire at Edenthorpe. In military use during the Second World War, the estate was sold in 1952 and the house demolished in 1955. A housing development now occupies the site.

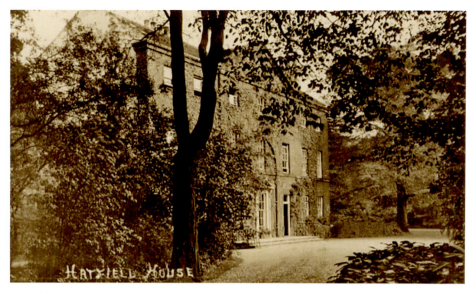

Hatfield House.

Hayfield, Glusburn

Originally built for James Hartley, a local worsted manufacturer, Hayfield was bought by his partner John Horsfall and massively extended into a shapeless Italianate jumble that would have pleased the Addams family. The architect may have been John Kirk of Huddersfield. It was later the home of Sir John Donald Bt and was eventually demolished as it was entirely unsuitable for modern living.

Hayfield.

Healaugh Hall.

Healaugh Hall, Tadcaster

Healaugh was a large, severe, classical house with a dominating central canted bay built by Benjamin Brooksbank in 1785 on the site of an earlier manor built by Lord Wharton, which in turn occupied a former monastic site. John Carr is said to have been the architect and the hall was typical of his style. The Brooksbanks had bought the estate in 1714. The house was restored by Edward Brooksbank following a fire in 1901 but was offered for sale in 1941. It failed to sell and was demolished in 1947. The Brooksbanks sold the estate in 1961.

Heath Old Hall, Heath, near Wakefield

Built about 1564 by John Kaye, deputy steward of the manor of Pontefract, Heath Old Hall has been convincingly ascribed to Robert Smythson and was very similar to his surviving Barlborough Hall in Derbyshire. A square block with a turret at each corner and an elaborate parapet, its state chamber contained a monumental chimneypiece with a scene depicting the death of Jezebel (now at Hazlewood Castle near Tadcaster). A long gallery ran along the first floor of the entrance front. During the sixteenth century Heath Old Hall was the home of Lady Bolles, the only women ever created a baronetess in her own right (by Charles II). Lady Bolles was a daughter of William Witham of Ledston Hall, to whose family the hall had passed. She is said to have been bewitched to death by Mary Pannal, an alleged sorceress who was later executed for the crime. Lady Bolles was buried at Ledston but was said to haunt Heath before its demolition. Lady Holles left 'all my beeves and fat sheep with two hogsheads of wine and several of beer' to furnish her wake. The hall then passed to Lady Bolle's grandson from an earlier marriage,

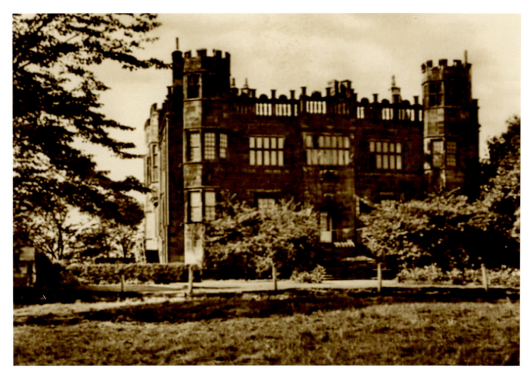

Heath Old Hall.

William Jopson, who was the last holder of the baronetcy. Jopson being childless, the hall was inherited by the descendants of one of Lady Bolles' daughters, who held it until the end of the eighteenth century when it was sold to John Smyth, whose great-great-grandson built the new hall nearby.

During the first half of the nineteenth century, the Old Hall was occupied first by nuns and then in 1865 by a girls' school.

The house remained with the Smyth family but became increasingly dilapidated, suffering the effects of subsidence and ongoing encroachment by nearby Wakefield. Further damage was done while the house was occupied by the army during the Second World War. Heath Old Hall was demolished in 1961. Dame Mary Bolles's well-house is all that survives.

Heaton Hall, Bradford

Heaton is first recorded, as Hetun, in 1160 when it was among land given to Selby Abbey by the Everingham family. After the Reformation the estate was sold to the Batts of Oakwell Hall. Heaton was the seat of the Fields from 1634 and the house was rebuilt by John Field after 1660. A Palladian remodelling was carried out a century later. On the death of John Wilmer Field in 1837 the estate passed to Lord Oxmantown, later 3rd Earl of Ross, who had married the Field heiress in 1836. The earl's widow lived at Heaton until her death in 1885 and thereafter the house was tenanted. Heaton was sold in 1911 to pay death duties. The hall was demolished before the Second World War. A school now stands on the site.

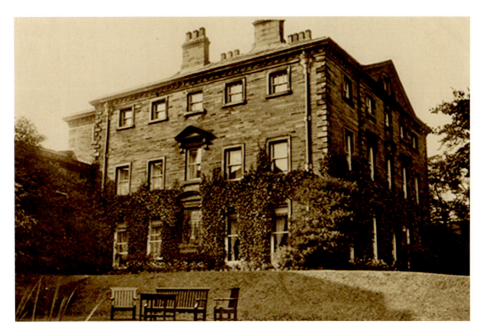

Heaton Hall, Bradford.

The house had a main block of five bays by five bays with a pediment over the central three bays of the garden front. A lower wing led from one side to a projecting wing with a two-storey canted bay. The house had fine eighteenth-century interiors and some rooms survived from the earlier house.

Hexthorpe Hall, near Doncaster

Hexthorpe Hall stood near Sprotborough and, like it, overlooked the River Don. Its nineteenth-century owners were the Ramsden family. Hexthorpe was sold in 1937 and demolished to make way for a housing estate. Dell Crescent stands on the site.

High Sunderland, Halifax

High Sunderland stood on moorland outside Halifax, built either by Richard Sunderland in around 1587 or his son Abraham in 1629. It was a severe stone mansion with mullioned windows and an early classical door with slightly wonky pillars on each side. The new building replaced an earlier timber-framed house. Carved figures stood over the entrance and an inscription requested that the family be allowed to 'quietly inhabit this seat ... until an ant drink up the waters of the sea, and a tortoise walk round the whole world'.

High Sunderland, which stood not far from Southowram, where she taught, is said to have been a model for Emily Brontë's *Wuthering Heights*. By the twentieth century the house had been divided into tenements. Mining caused the walls to sag and by the 1950s High Sunderland was ruinous.

In the 1940s the owner, Mrs Holden, offered the house to Halifax Corporation and the Brontë Society, but both felt the costs of restoration prohibitive. Parts of

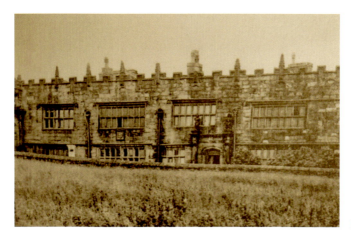
High Sunderland.

the house were saved for reuse and some decorative stonework and a gateway are in Bankfield Museum.

Holmes Hall, near Rotherham

Holmes Hall was a property of the Howards, dukes of Norfolk, and like Kimberworth became part of the dower estate. It later passed to the earls of Effingham, a junior branch of the Howard family. In the eighteenth century, with increasing industrialisation, the Howards moved to their estate at Thundercliffe Grange. The house passed into the hands of the Habershon family and was rebuilt or remodelled around 1850. Once again increasing industrialisation drove them out, this time to Ferham House. Holmes Hall was later demolished and the site used for industrial purposes.

Hooton Levitt Hall, Maltby

Hooton was a Georgian house of three bays with a parapet. In the nineteenth century a half-timbered wing was added. Hooton Levitt was inherited by William Fretwell Hoyle, who died in 1886. Hooton Levitt was demolished in 1964. The site is now covered with modern housing.

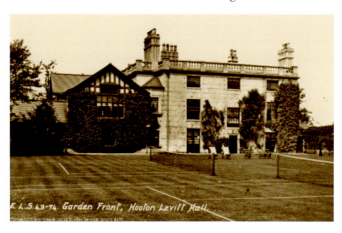
Hooton Levitt Hall.

Hooton Roberts Hall.

Hooton Roberts Hall, near Rotherham

Hooton Roberts was a seat of Thomas Wentworth, Earl of Strafford (1593–1641) and later of his widow. The house dated from the late sixteenth or early seventeenth century and was demolished many years ago.

Horsforth Hall, Leeds

Horsforth Hall was built by John Stanhope between 1699 and 1702. It was altered in the 1760s for a later John Stanhope by John Watson. In 1930 the house was bought by Mr and Mrs William Matheson and given to the town. This gesture was to no avail and the house was demolished in the 1950s.

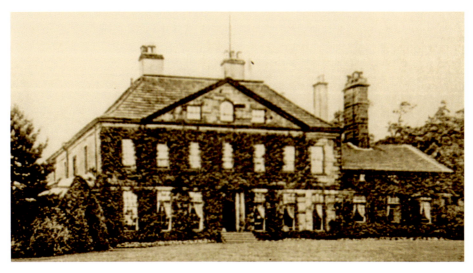

Horsforth Hall.

Horton Hall, Bradford

Horton Hall was one of two houses on Little Horton Green that belonged to branches of the Sharp family (the other was Horton Old Hall). The Sharps had been resident in the area since the thirteenth century. During the Civil War the Sharps of Horton Hall were Parliamentarians; their cousins at the Old Hall, Royalists. The hall was rebuilt around 1677 by Thomas Sharp, incorporating a late medieval timber-framed building. The new version had a central low tower containing the entrance door with a rose window above and a diamond-shaped window to the top storey. Broad mullioned windows lit the rooms on either side of the tower at ground- and first-floor level and there was originally a projecting wing at each end with a Dutch gable. In 1694 the astronomer Abraham Sharp, friend of Isaac Newton, built an observatory in the tower. Around 1800, one of the gabled wings was removed and a new classical block was built with two bays either side of a large, canted bay window.

Members of the Sharp family included John Sharp, Archbishop of York, and his grandson Granville Sharp, the distinguished anti-slavery campaigner. The Yorkshire antiquary Edward Hailstone lived at Horton. An earlier tenant, John Wood, was instrumental in bringing forward legislation limiting the length of the working day in factories to ten hours. The hall was later used as the Bishop's Palace and was demolished after a fire in 1965.

Horton Old Hall, Bradford

Horton Old Hall was built by Isaac Sharp in 1675. The last owner of the estate, Francis Sharp Powell, lived in the Old Hall, which was demolished in the late 1960s. Much of Little Horton remains protected from development and is in the ownership of the Powell estate trustees.

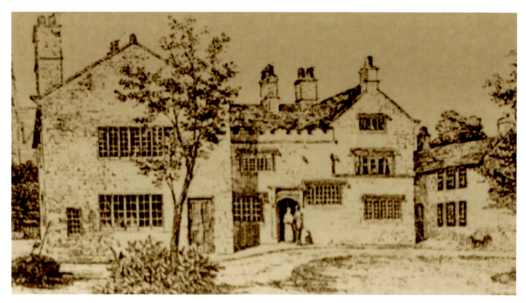

Horton Old Hall.

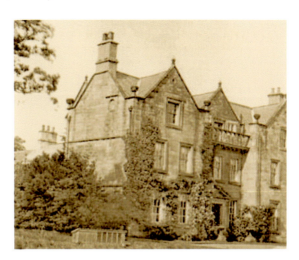

Howarth Hall.

Howarth Hall, Rotherham

Little is known about Howarth Hall, which was demolished in 1965. Charles Laughton was living at his 'old family seat' of Howarth in 1625. After the death in 1687 of Dorcas, wife of John Laughton, the estate passed to her nephew Thomas Westby. Westbys continued to live at Howarth in the eighteenth century. Various residents are recorded in the nineteenth century and in 1901 George Saville lived in the hall. Howarth is said to have contained a priest hole.

Howley Hall, Morley

Howley Hall was a major Elizabethan house built around a 60-yard square courtyard with corner towers each adorned with a cupola. It was built by Sir Robert Saville and his son John (of Methley) around 1590 at a cost of £30,000. Howley was besieged during the Civil War and was occupied by the Savilles until the death of Sir James Saville in 1671. The hall later passed by marriage to the Brudenell family. After this it was tenanted and appears to have fallen gradually into disrepair. Stone from it was used to build the Old Presbyterian Chapel at Bradford and other local buildings. The house was demolished on the orders of Lord Cardigan between 1717 and 1730. Its ruins survive.

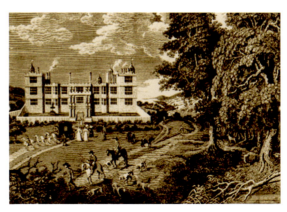

Howley Hall.

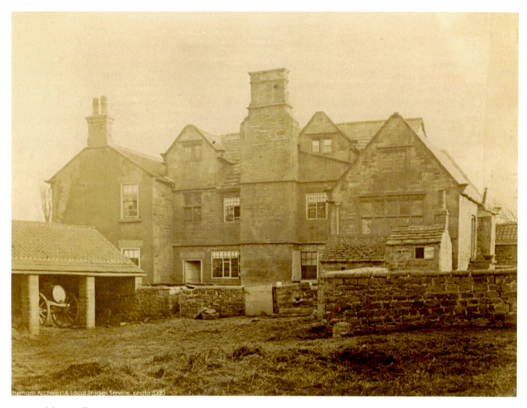

Ickles Hall.

Ickles Hall, Rotherham

Ickles was built in the 1580s on the site of an earlier house for Thomas Reresby, whose family had owned the estate since 1250, although their main estate was Thrybergh. It was later used at various times as a dower house or house for the eldest Reresby son, Thrybergh being the main family seat. A west wing with a banqueting hall was added in 1610 and an east wing in 1620. By the eighteenth century the hall had passed through a series of marriages to the Fullerton family, who let it as a farmhouse. From 1900 Ickles was owned by Hannah Wood and occupied by the Picken family. In 1905 the west wing was demolished. The remainder of the hall was pulled down in 1939 and the site sold to United Steels.

Ingmire Hall, Sedburgh

Ingmire Hall was a huge, rambling Gothic house with an ancient core dating from the sixteenth century and a defensive (pele) tower. The hall was enlarged in 1838 for John Upton, probably by George Webster of Kendal. Further additions were made at the end of the nineteenth century. In the seventeenth century Ingmire was the home of Sir John Otway, and it was later the seat of the Upton family. In 1897 the owner was Mrs Upton-Cottrell-Dormer. In 1922 the house was sold by Major John Upton. Ingmire was partially burnt down in 1928, but was reconstructed by Sir T Strickland. The hall was remodelled in 1989 and remains a private home.

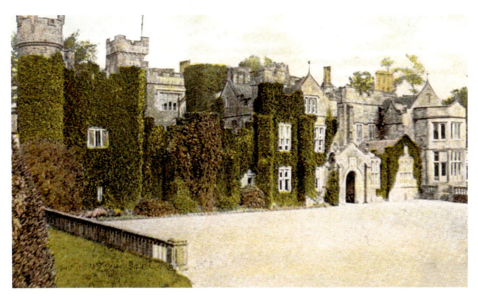
Ingmire Hall.

Killingbeck Hall, Leeds

The original Killingbeck Hall of the Brooke family survived in the grounds of its successor until the 1860s. The new house was built in the early eighteenth century, but the estate was sold by William Brooke to the Hansom family of Osmondthorpe in 1788. After a period standing empty, the estate was sold to Leeds Corporation in 1898 and became part of Killingbeck Hospital. The hall was not demolished until 1978.

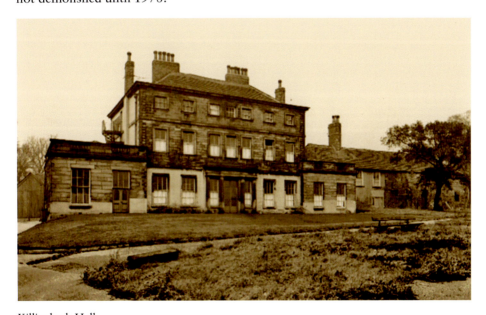
Killingbeck Hall.

Kippax Hall, Kippax

Kippax Hall, not to be confused with Kippax Park, was a rather Addams Family-esque Gothic mansion built in the late nineteenth century for the Breffit family. The hall was later divided by W. M. Green and used by his family. Kippax Hall was demolished after 1987 and a surgery now stands on the site.

Kippax Park, Castleford

Kippax, demolished after 1953, was astonishing. The estate was bought by Thomas Bland in 1595, after which he built a grand Elizabethan house of three floors and nine bays. John Bland, 6th Bt, inherited in 1743 and subsequently spent a fortune extending the house to designs attributed to Daniel Garrett. Two canted bays were added to the main block and huge classical wings appeared on either side. The completed house, of thirty-seven bays and around 600 feet, made it one of the longest houses in England. Sir John bet the owner of Wentworth Woodhouse that Kippax Park was longer. He lost – just. In 1755 after losing £32,000 in a night's gambling, Sir John fled to France before dying by suicide. The last Bland to live at Kippax died without an heir in 1928. There was a sale of its contents and the house was left to decay. Derelict by 1953, the park was gradually destroyed by opencast mining and the house was demolished as mining progressed. Kippax is one of the most significant losses amongst Yorkshire houses.

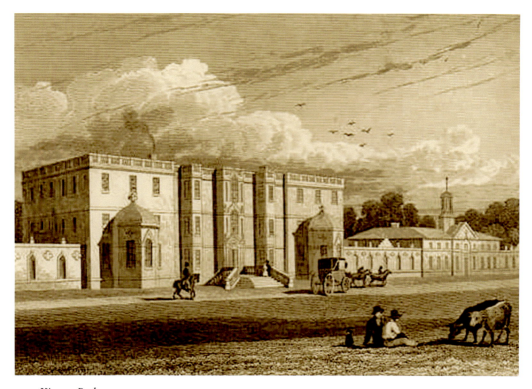

Kippax Park.

Kirby Hall, Little Ouseburn

Kirby Hall was designed in the late 1740s by Roger Morris with the assistance of Lord Burlington, and built between 1746 and 1756 for Charles Thompson, a London merchant and money broker whose family had had estates at Little Ouseburn since 1635. John Carr was also involved and was responsible for many of the interior details. The house was said to contain work by Grinling Gibbons and Sir James Thornhill that had been removed from Canons Park. Anne Brontë used Kirby Hall as a model for Ashby Hall in her novel *Agnes Grey*.

A conservatory was added in 1833 by J. B. Papworth, who also landscaped the park. A wing added in 1800 was pulled down in 1857 and replaced with a much larger extension. Paxton built greenhouses at Kirby in 1863.

It is no surprise therefore that the demolition of Kirby Hall in the early 1920s was one of Yorkshire's greatest architectural losses. Charles Thompson's descendant, Sir Harry Meysey-Thompson, was created a baronet in 1874. Kirby Hall was demolished after Henry Meysey-Thompson, son of the 1st Baronet and himself created 1st Baron Knaresborough in 1905, lost interest in the future after his only son and heir Claud Meysey-Thompson died of wounds received on the Western Front in 1915. Father and son lie in the beautiful churchyard of Great Ouseburn not far from the site of the hall. The nearby mausoleum built in the mid-eighteenth century for Henry Thompson has recently been restored.

Kiveton Park (Keeton Park), Kiveton

The eleven-bay house had a tetrastyle engaged portico and pediment and a forecourt formed by a pair of single-storey pavilions with hipped roofs and dormers. It was built by William Talman for Thomas Osborne, 1st Duke of Leeds (in Kent) between 1698 and 1704 to replace Thorpe Hall. The interior included painted decoration by Laguerre and Thornhill and wrought ironwork by Tijou. Kiveton Park was demolished in 1811 by the 6th Duke, who moved his seat to Hornby Castle. The estate remained in the Osborne family and was later mined for coal. It was broken up and sold in the early twentieth century.

Knoll (The), Baildon

The Knoll was built in 1858 for Charles Stead, partner in Sir Titus Salt's Saltaire Mills. It was a high Victorian Gothic pile with a tower and a bellcote on a gable end. Stead lost the house following the failure of Salt and Company. The Bradford Bank sold it to James Roberts who later moved to Milner Field. In 1919 The Knoll was sold to William Root. Various owners followed, none staying very long. The house was divided into flats before being demolished in 1961. Council housing was built on the site.

Knostrop (Knowsthorpe) Old Hall, Leeds

The Old Hall was a seventeenth-century house with a two-storey porch built by the Baynes family, one of whom, Adam Baynes, was Leeds' first MP during the Commonwealth. The Victorian artist W. Atkinson Grimshaw lived at Knostrop Hall in the 1870s and painted characteristic moonlit images of the house. Knostrop Old Hall was demolished in 1960.

Knottingley Old Manor House, Knottingley
The old manor house of Knottingley was built in the seventeenth century and stood close to St Botolph's Church. For 150 years, until 1787, the manor house was the home of the Ingram family. The house was then divided and the west wing demolished. The remaining east wing was the Swan Inn for 150 years. The Old Manor House was demolished in the 1960s.

Knottfield House, Rawdon
Knottfield House was built in the 1840s to the designs of the Bradford architects Milnes and France for John Dawson of Kirkstall Brewery. It was next occupied by Herman Averdieck, a stuff (coarse, woven cloth) manufacturer born in Hamburg in 1822 and a close friend of Sir Charles Hallé, who was very involved in musical life in Bradford. After the First World War, Knottfield became the Mitchell Memorial Home for ex-servicemen suffering from tuberculosis. It was later run by the West Riding County Council as a home for boys and was demolished in 1959. Rawdon Crematorium now stands on the site.

Knowsthorpe Hall (Knostrop New Hall), Leeds
Knowsthorpe was built for Abraham Rhodes. The garden front had a central curved bay and shallow dome and there were matching pavilions connected to the house by single-storey one-bay links. The house later belonged to the Leather family. It was demolished in the early 1960s.

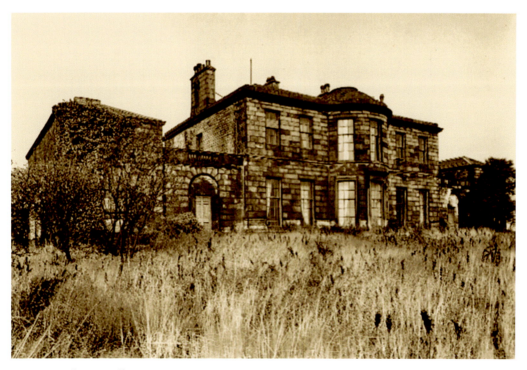

Knowsthorpe Hall.

Littlemoor, Queensbury

Littlemoor was a fantastic Scottish baronial-style mansion built for the fabulously wealthy Herbert Foster, partner in the Black Dyke Mills. The house was left empty after his death and his widow gave the estate to the council in 1953 for recreational use. Surplus to requirements, the house was demolished.

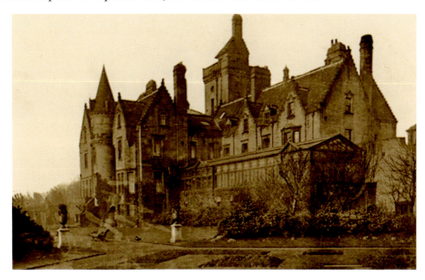

Littlemoor.

Lower Hall, Liversedge

Lower Hall was built around 1660 by William Greene. It was stone-built with three gables and large windows. There was a projecting porch between the middle and the right-hand gable. The house was later in multiple occupation. The site of Lower Hall is now covered by housing.

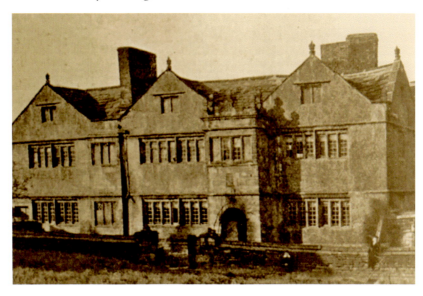

Lower Hall, Liversedge.

Lord's House, Sheffield

The dukes of Norfolk had substantial estates in and around Sheffield and the Lord's House was built in 1711 for their occasional visits. The architect ('surveyor and carpenter') was John Stanley, who prepared designs at a cost of £2 3s. Lord's House was more often occupied by agents of the dukes. Lord's House was demolished in 1814.

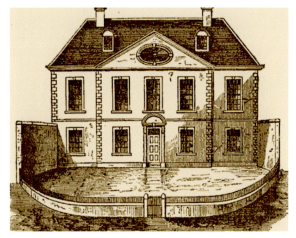

Lord's House.

Lydgate Hall, Sheffield

Lydgate Hall was the home of Horatio Bright, prominent in the iron and steel industry. Bright's wife and only son died tragically young. Both were interred in a specially built mausoleum, the interior of which was sumptuously furnished and contained an organ. Bright was known to visit the mausoleum regularly, playing the organ while staff dusted the coffins. His wife's coffin contained a glass window so that Bright could look at her face. The hall, which by then was largely derelict, was demolished in 1938 and the land used for a housing development. Sadly, recent vandalism has caused the bodies of the Bright family to be reburied elsewhere.

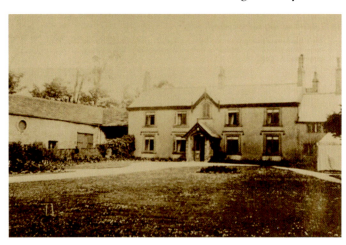

Lydgate Hall.

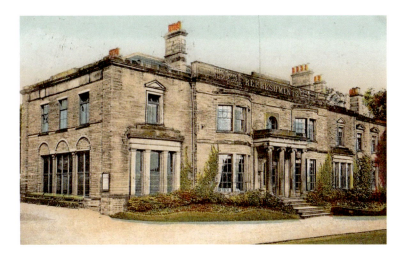

Manningham Hall.

Manningham Hall, Bradford

Manningham Hall stood where the Cartwright Hall Art Gallery now stands. The estate was the seat of the Lister family, who acquired it from the King family in the fifteenth century. The hall was built around 1770 on the site of an earlier building. Simon Cunliffe Lister, later 1st Baron Masham, sold the hall and park to Bradford Council for less than the market value in 1870, stipulating that the land was used as a public park. After a period of use as a restaurant, the house was demolished in 1903.

Manor Heath, Halifax

Manor Heath was a Gothic villa on the edge of Halifax designed by the London architects Parnell and Smith and built in 1852–53 for John Crossley, the carpet manufacturer. It was bought by Halifax Corporation in 1929 and demolished in 1958.

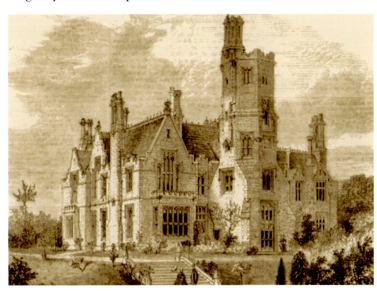

Manor Heath.

Methley Hall, Leeds

In the eleventh century Methley was the manor of Ilbert de Lacy. Its rents were later donated to the Hospital of St Nicholas at Pomfret (Pontefract). The lands passed by exchange to John Waterton, household comptroller to Henry V. Methley Hall was bought by Sir John Saville from descendants of the Watertons in 1588 and extensively remodelled by Sir John and his son, Sir Henry. Sir John's brother was tutor in Greek to Queen Elizabeth I. The Savilles subsequently became earls of Mexborough.

The house was classicised in the eighteenth century by John Carr at the request of the 1st Earl of Mexborough when a suite of classical rooms was added to the south front. A vaguely Elizabethan appearance returned under Anthony Salvin in 1830–36. Salvin completely destroyed Carr's work, adding Tudor towers and producing a rather unsatisfactory result that could never have been mistaken for genuine sixteenth-century work, although the old north-west wing was retained.

In 1916 the 5th Earl died without children and Methley came to his half-brother, who was already settled at Arden Hall on the North York Moors. As a result, Methley became little more than a shooting box, remaining unoccupied until requisitioned by the army during the Second World War. The best furniture was lent to Temple Newsham, while other pieces were sold.

When the house was returned to the family it was in very poor condition and all attempts to develop it as a hotel or institution failed, at least in part because of surrounding opencast mining and subsidence. Methley Hall was demolished in 1963 after a sale of the contents. Some fittings were moved to Arden Hall. The estate remains in the Saville family.

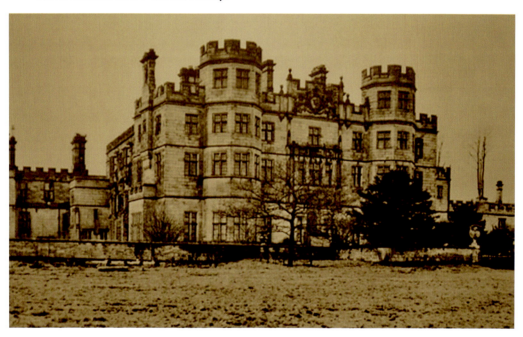

Methley Hall.

Millbank Hall, Luddendenfoot

Now derelict, Millbank Hall was built in the first decade of the nineteenth century, probably for William Currer, who died there in 1807. The house is classical with a Doric portico. The main façade had tripartite windows under relieving arches.

Milner Field, Saltaire

Milner Field was originally a manor house built, or was possibly rebuilt in 1603 by John Oldfield. The hall had a gallery running round it giving access to the first-floor rooms. In 1834 the manor house and its lands were sold to John Field, whose daughter sold the property to Titus Salt Jr in 1869. Salt was the son of Sir Titus Salt Bt, mill owner and philanthropist whose greatest achievement was the suburb of Saltaire, which stands as a memorial to his vision of high-quality workers' accommodation and recreational facilities and is believed to have cost Salt £250,000. Salt Jr demolished the old hall to build his new mansion, retaining only the gateposts and the date stone with the initials of John Oldfield and his wife.

The new Milner Field was a striking composition, built in what was described by Mark Girouard as 'Wagnerian Gothic'. Salt Jr had married a Crossley, uniting two great philanthropic dynasties of nineteenth-century West Yorkshire. The architect was Thomas Harris and there is no evidence to support the involvement of Richard Norman Shaw, although the façades and planning of the interior were certainly highly competent.

Miner Field was built between 1871 and 1873. There were towers, machicolations, arches and a variety of gables. The kitchen was octagonal and based on that at Glastonbury Abbey. The interior was decorated to the highest standard with medieval murals and stained glass, and the dining room fireplace had a painted triptych of medieval figures. The hall was dominated by a three manual organ and connected by a telephone cable to the offices of Salt's mill. Some of the furniture for Milner Field is now at Lotherton Hall.

The Prince and Princess of Wales were entertained at Milner Field in 1882. Salt Jr was active in the family business and followed his father's habit of philanthropy. Millner Field was also the centre of a social circle, including the very highest levels of Victorian society.

Titus Salt Jr died unexpectedly at the age of forty-four in 1887. In 1892 Sir Titus Salt Bt Sons & Co. went into liquidation and the house was acquired from Mrs Salt by James Roberts in 1903. Roberts set about restoring the fortunes of Salt & Co. and the Roberts occupied the house until 1918, maintaining a lavish lifestyle and furnishing the house in a French style.

Roberts' eldest son James died aged twenty-four in 1898, his youngest son drowned aged eight in 1904 and his son Bertram died at the age of thirty-six in 1912. When his only surviving son was invalided out of the army during the First World War and unable to work again, Roberts, by then a baronet, decided to sell the business and retired to Scotland. Roberts is said to have been the inspiration for the reference to 'a silk hat on a Bradford millionaire' in T. S. Eliot's *The Waste Land*. They first met when during a trip to Roberts' bankers in London, the bank official he met turned out to be Eliot, who was working there at the time.

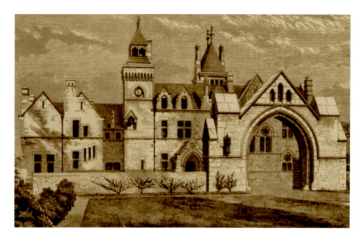
Milner Field.

Roberts bought and donated Haworth Parsonage to the Brontë Society. Milner Field was put on the market in 1922 but failed to sell. The mansion was next occupied by the mill owner Ernest Gates, who died in 1925. Its final occupants were Arthur Hollins and his family, who, like Gates, ran Salts Mill. The Hollins left Milner Field in 1930 and the company tried to sell it. Unsold, the house stood empty and deteriorating, gathering a reputation locally for ghostly activity. Milner Field was demolished with explosives in the 1950s. Only fragments survive.

Milnsbridge, Huddersfield

Milnsbridge was the seat of the Radcliffe family, originally from Radcliffe Tower in Lancashire. Radcliffes had owned Ordsall and Smithills halls in Lancashire and held the earldoms of Derwentwater and Sussex. Sir Joseph Radcliffe, 1st Bt, inherited Milnesbridge from a maternal uncle in 1785, changing his name from Pickford to Radcliffe. He was given a baronetcy for his actions as a magistrate in dealing with industrial unrest in the West Riding. In 1829 Milnsbridge and its environs were described in the following terms:

> The valley in which the house is situated is of the most fertile and beautiful description, it is bounded by hills rising above each other to a considerable height and cultivated to the summit. The house is built with stone of correct architecture, consisting of a plain centre, having a pediment enriched with scrollwork, and two wings in corresponding design. The shrubbery that adjoins the house is disposed with much taste. In the front the lawn is bounded by two detached pools of water beyond which runs the rich prospect of the adjacent country.

Radcliffe's grandson and successor purchased Rudding Park near Harrogate. Having been engulfed by the industrial growth of Huddersfield, Milnsbridge was sold by the Armitage family who owned it until 1919 when it was bought by local freemasons with the intention of it becoming a lodge. The mansion had been divided into multiple dwellings since 1870. The masonic lodge plan fell through and Milnsbridge became industrial premises.

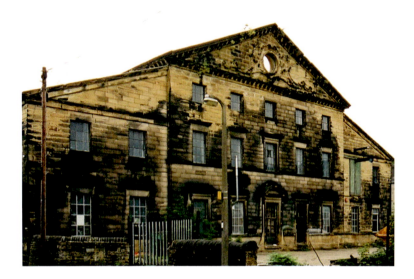
Milnsbridge House.

Moorside, Halifax
L. J. Crossley, a member of the third generation of the Halifax carpet-making dynasty, was an enthusiastic amateur scientist with a particular enthusiasm for electrical gadgets. The entrance hall of his house, Moorside, contained a magnetic clock with a driving weight of half a ton, but the most striking feature was an immense organ with the console in an anteroom, the pipes in the drawing room and a swell organ in the cellar. Holes in the drawing room floor allowed the sounds of the swell organ to reach listeners upstairs. The architect was H. J. Paull of Manchester. Moorside has been demolished.

Moorville, Burley in Wharfedale
Only a fragment survives of the Scottish baronial house built in 1848 for the Leeds stuff dyer J. H. Whitehead. Moorville was the home of the textile-manufacturing Hudson family for the rest of the nineteenth century. Edward H. Hudson enlarged the original mansion, producing a huge house with two towers. Moorville was later a youth hostel.

Morley House, Leeds
The Scatcherds' Morley house was a three-storey brick house with stone dressings. There was a Venetian window over the central doorway with a Diocletian window at second-floor level. Norrison Scatcherd wrote a history of Morley (1830). The house was later the home of R. Borrough Hopkins. Morley House was demolished in the 1930s.

Netherwood Hall, Wombwell
Netherwood was an early eighteenth-century house of seven bays. It stood near the River Dove on the site of the former manor of Woodhall, which dated back to the fifteenth century or earlier. In the fifteenth century the manor was occupied by the Drax and Bosville families. In 1516 the records of the Court of the Star

Chamber record the siege of Woodhall involving a priest named Thomas Drax. From around this time the name Netherwood Hall came into use. In 1603 Ralphe Woodcock occupied Netherwood, but two years later the Bosvilles were back.

Netherwood passed to the Taylors in the late seventeenth century and then through a series of owners, including the Foulstones, Batties, Walkers, Morleys and Rocks. In 1777 the estate was purchased by the clothier and cloth dresser John Garland of Leeds, and it remained in the Garland family until the late 1890s when it was sold to Mitchell Main Colliery Company. First used as the residence of the Mitchell family, it then became the home of John Halmshaw, the colliery manager. From 1924 it was used as offices then as a miners' welfare club. It was offered to the local district council, but the offer was declined. Netherwood was demolished in the early 1960s.

New Hall, Attercliffe

Richard Frankland set up a dissenting academy at Attercliffe Hall in 1686. In 1689 the academy was taken over by Timothy Jollie, whose students included Thomas Secker, later Archbishop of Canterbury. In 1798 the hall, which had clearly been rebuilt in the eighteenth century, belonged to R. Swallow. The grounds of New Hall later became pleasure gardens and the house was demolished.

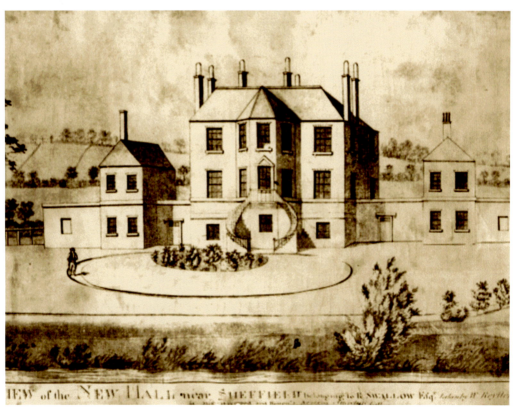

New Hall Attercliffe.

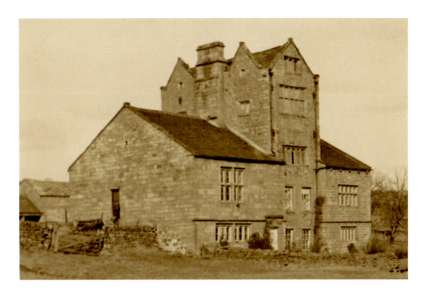

Newall Old Hall.

Newall Old Hall, Otley

Newall Old Hall belonged to the Fawkes family in 1275 and stood around 3 miles from the present Fawkes' seat at Farnley. It included a pele tower and additions of various dates. The porch, erected in 1624, was later removed to Farnley Hall, where it remains. The hall later deteriorated before being used as a farmhouse. The wings were demolished in 1827 and replaced, surviving until they were removed between 1908 and 1921. Newall was demolished in 1928 to make way for a council housing programme by Otley Council. Turner painted Newall Old Hall on a number of occasions. The site is now a playground and playing fields.

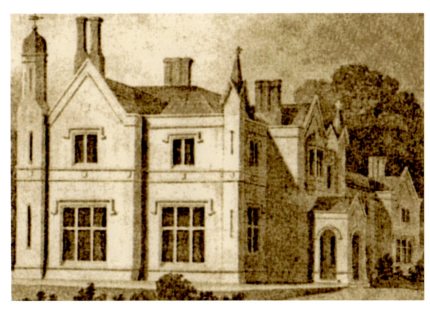

Newlaithes Hall.

Newlaithes Hall, Horsforth

An early Tudor revival building designed by Robert Lugar and replacing an earlier building simply called Newlaithes, Newlaithes Hall was the seat of the Pollard family. When new, Newlaithes hall was described as a 'commodious and respectable mansion with well laid out pleasure grounds'.

The cellars of the hall were reported to include twelfth-century arches and there was apparently a tunnel leading from the hall – said to have been used by monks to reach Kirkstall Abbey. Newlaithes Hall was severely damaged by fire but was rebuilt and divided into two houses. During the Second World War, Newlaithes was used to house German prisoners of war. It was demolished in 1964 and the grounds built over.

Newland Hall, Normanton

The site of Newland Hall was previously occupied by a Knights Hospitaller's preceptory. The Sylvester family bought the estate in 1694 and the house was rebuilt, probably by Sir John Sylvester Smith, who died in 1746. Smith's grandson Sir Matthew Dodsworth (d. 1856) sold the property to William Locke. The house was demolished in 1920, but the stables, dated 1745 and bearing the names of John Smith and his wife Anne, survive in ruinous condition. Two pillars from the house are now at Thornton Watlass Hall in North Yorkshire, which is now the seat of the Smith-Dodsworths.

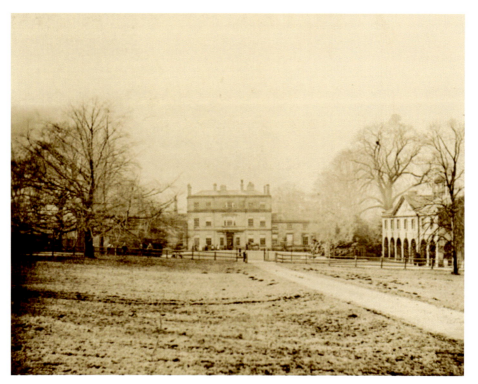

Newland Hall.

Norland Hall, Norland
Norland was a timber-framed house of the mid-fifteenth century re-fronted in stone by Joseph Taylor in 1672. In 1690 John Taylor of Norland Hall built Norland Upper Hall for his younger son. In 1912 the hall was struck by lightning and subsequently fell into increasing dereliction. There were originally plans to rebuild the house in Croydon, but these were abandoned as a result of the First World War. The stones of Norland Hall were eventually bought by William Randolph Hurst and shipped to America. Again, reconstruction at San Simeon came to nothing and the stones were used to build a Presbyterian chapel and other buildings.

Norton Lees Hall, Sheffield
A mainly seventeenth-century house built around an earlier core, Norton Lees Hall had three storeys and three gables on the south front, those on the other façade having been largely removed in the eighteenth century. The hall was the home of the Parker and Barker families. Norton Lees had a particularly fine eighteenth-century staircase, which in 1931 a Clydesdale horse was ridden up to demonstrate its strength. Norton Lees Hall was demolished by the local council in the 1950s.

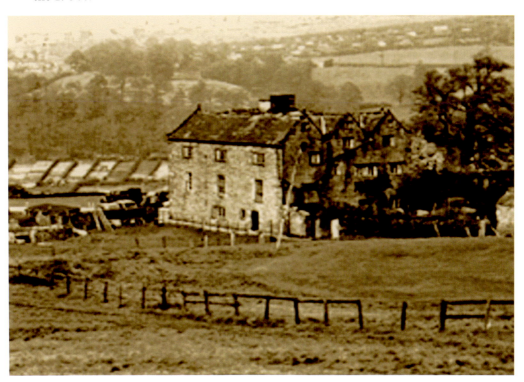

Norton Lees Hall.

Norwood Hall (Bishopholme), Sheffield

The Rawsons owned Norwood from at least 1553 until 1666, but the core of the hall, a Queen Anne block with two small pediments and asymmetrical wings on either side, was built about 1713 for William Taylor. From 1775 to 1915 Norwood was the home of the lawyer James Wheat and his descendants. James Wheat added a wing to the house, built the stables and laid out the park. James' grandson John James further enlarged the house to accommodate his thirteen children. The hall was sold to Sheffield Council in 1916. In 1918 it became the residence of Leonard Burrows, first bishop of Sheffield, and its name was changed to Bishopholme. The city council reacquired the hall after Burrow's retirement, using it as a home for homeless families. Attempts were made to save at least the core of the house, but after a period of increasing decay the house was demolished in 1976.

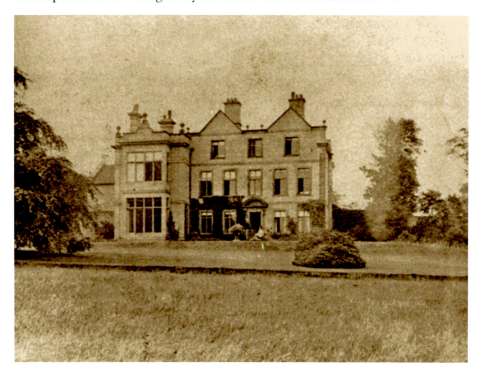

Norwood.

Oakworth House, Keighley

Sir Isaac Holden was a wool trade millionaire and inventor with interests in France and Yorkshire. Isaac began his working life as a mill boy. Continuing his education in his spare time, he became a teacher and in 1829 while teaching in Reading invented a Lucifer match, which used sulphur between the combustible material and the wood. Following a period of poor health, he became a bookkeeper in a mill where his curiosity and inventing talents led to a wool-combing machine and further patented processes which made him a millionaire. At its zenith, Holden's mill employed 4,000 people.

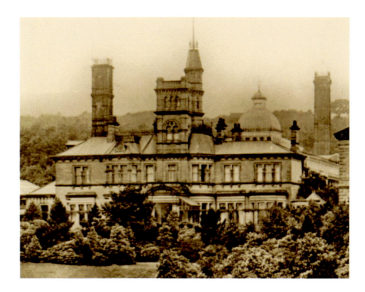
Oakworth House.

Suffering once again from ill health, Holden retired from industry to take up politics, serving as MP for the West Riding and then for Keighley. He was widely considered to be the wealthiest member of the House of Commons. He was made baronet in 1893 and died in 1897.

Oakworth was his second wife's family home, bought by Holden from her brother Jonas Sugden and transformed by the Bradford architect George Smith. The house had vaguely French detailing with a tower and turret, and the estate was a model of contemporary technology. Unusually, the house had its own suite of Turkish baths. There was also a small telephone room by the mid-1880s, allowing Holden to speak to the post office, his sons, his sons-in-law, office and works. Living largely on fruit, Holden's dietary idiosyncrasies were serviced by forty hot-houses he built in the grounds of his home.

The house burnt down in 1909 after a period of dereliction, but a portico survives. The site was later given to Oakworth by Francis Illingworth, Sir Isaac's grandson, for use as a public park.

Odsal House, Bradford
Odsal was built by John Hardy, partner in the Low Moor Iron Company around 1795, which was about half a mile from the house. Inevitably demolished after the ironworks engulfed it, a fragment of the garden survives as a sports field.

Orgreave Hall, Rotherham
Orgreave Hall was demolished as late as the 1990s as a result of opencast mining. The stone and some architectural components apparently have been reused elsewhere or remain in storage. The hall was built or substantially remodelled around 1684 by William Harrison and his wife Ann (the lintel above the door was inscribed 'WHA 1684'). In the early nineteenth century it was owned by the Sorby family, who established a tool-making business. Orgreave was used as a sports club before its final demolition.

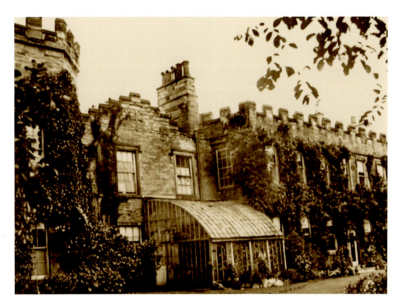
Outwood Hall.

Outwood Hall, Wakefield
Outwood was built around 1700 by the Armytages of Kirklees and rebuilt in Gothic style by Joseph Armytage in 1816. The estate passed by marriage to Revd Richard Lucas in 1820. In 1889 it was sold to a Mr Carter, and two years later half the estate was sold to the Lofthouse Colliery Company. The hall and the other half of the estate eventually came into the ownership of Stanley Council. The estate was built over for housing in the 1930s and the hall demolished.

Painthorpe Hall, Barnsley
When Painthorpe was sold in 1787 it was described as 'a handsome modern-built mansion house with stables, barns ... and 43 acres in a ring fence lying in front of the house and very suitable for the residence of a gentleman's family'.

In the early nineteenth century Painthorpe was the home of the Heaton family, for whom John Carr carried out alterations. Painthorpe has been demolished.

Park Hill Hall, Firbeck
The first records of Park Hill date from the early 1600s when the house, then known as Gawkhill Hall, was occupied by a member of the Saunderson family of Sandbeck. In 1685 it belonged to Thomas Chadwick, who sold it that year to Nonus Parker. On Parker's death in the 1730s the hall passed to his daughter Mrs Singleton, who in 1754 sold it to Thomas Fowke, Governor of Gibraltar. Fowke sold the estate on to the trustees of Thomas Thornhill. In 1765 the estate was acquired by Anthony St Leger. Although the first 'official' St Leger was held on Cantley Common in 1776 before moving to Doncaster Racecourse in 1778, according to local legend the race was previously run at Firbeck.

Park Hill passed to St Leger's nephew, John Hayes St Leger, in 1786. St Leger was a friend of the prince regent and Groom of the Bedchamber. He had a reputation as a rake and never married, the estate passing to his brother and then

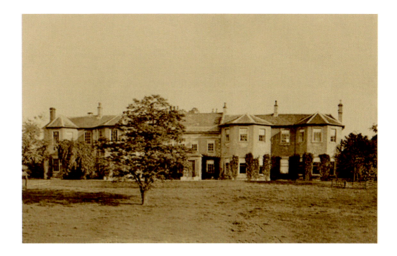
Park Hill House.

his nephew Anthony, who died childless. Park Hill was inherited by John Chester, Anthony's uncle on his mother's side, who took the name St Leger.

The house and estate were sold in 1909 and the house was then used as a girls' school. After the Second World War, the house was occupied by the Hayes family, and it was later used as a village hall. The hall and estate were bought in 1935 by Cyril Nicholson and the house demolished.

Parlington Hall, Aberford

The Gascoignes are said to have come from Gascony, settling in Yorkshire in the Middle Ages. In 1546 they acquired the Parlington estate from the Wentworth family. The later classical house, built by Sir Thomas, probably incorporated parts of an earlier mansion illustrated by Buck.

Sir Thomas Gascoigne was created a baronet in 1602 and the estate descended in the direct male line until the death of the 8th Baronet, Sir Thomas, in 1810. Sir Thomas' son had predeceased him, dying in a hunting accident.

On the death of the 8th Baronet, the Gascoigne estates were left to Richard Oliver (later Gascoigne), the husband of his stepdaughter, who took the name of Gascoigne. Richard was a noted racehorse owner, winning the St Leger twice. The Olivers, descended from an officer in Cromwell's army, had substantial estates in Limerick and Lotherton was probably bought to provide a legacy for his younger children, the oldest son, Thomas, being expected to inherit Parlington.

Unfortunately, Richard and both his sons died within a year, and in 1843 the estates passed to his daughters, Mary Isabella and Elizabeth. The sisters built almshouses, schools and churches across their estates and Isabella was a noted wood turner, publishing a book on the subject (*The Handbook of Turning*). Isabella married Colonel Frederick Charles Trench of Woodlawn, County Galway, in 1850 and two years later Mary married Frederick's cousin Frederick Trench, 2nd Baron Ashtown. The sisters built Castle Oliver on their Irish estate. Elizabeth and her husband lived there, while Isabella and her husband lived at Parlington Hall until she died in 1891. The sisters sold much of their art collection to fund famine relief during the Great Famine.

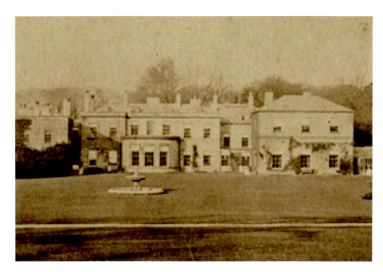
Parlington Hall.

Following the death of Isabella's husband in 1905, Parlington Hall was abandoned. Isabella's son Colonel Frederick Richard Trench-Gascoigne was already established at Lotherton Hall to the east of Aberford, which he had inherited on the death of his aunt. Many of the contents and architectural elements of Parlington were transferred to Lotherton. Only a fragment of the western part of the house at Parlington survives.

The estate was sold in 1964 but remains largely intact, together with the arch designed by Thomas Leverton erected to 'Liberty in N America Triumphant MDCCLXXXIII', a sentiment that caused the prince regent to refuse to visit, staying at Hazelwood instead. At nearby Aberford is a group of Gothic almshouses built by Mary and Elizabeth Gascoigne in 1844.

Pontefract New Hall, Pontefract

Pontefract New Hall was built around 1560, probably by Robert Smythson, pre-eminent Elizabethan architect and designer of Hardwick Hall, for Edward Talbot, later 8th Earl of Shrewsbury and Bess of Hardwick's stepson. Talbot was at one time accused of attempting to murder his brother Gilbert in order to inherit the earldom, by arranging for his physician to poison Gilbert's gloves. The physician was condemned to imprisonment and loss of his ears. Talbot eventually inherited estates much reduced during the tenure of his brother.

The house was symmetrical and a little reminiscent of Fountains Hall. There were projecting wings at each end of the façade with a central canted bay, each angle between the façade and the wings contained a further rectangular bay. At each end and set back was a higher tower probably containing a staircase. The ground floor contained service rooms, the first the state rooms and the second a long gallery and bedrooms.

Pontefract New Hall was derelict by the early eighteenth century. Later, part of it was used as a farmhouse. The roof was removed in 1812, but the ruins were only finally blown up in 1965. Stone from the remains was used in the construction of Wentbridge Viaduct.

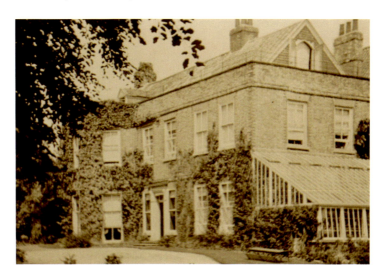

Poppleton Hall.

Poppleton Hall, Nether Poppleton

Poppleton Hall was a small Georgian villa with pleasure grounds running down to the Ouse, probably built by John Fothergill, who sold it in 1797. Later occupiers included Isaac Spencer, twice Lord Mayor of York. The house was a convalescent home after the Second World War and was demolished in the 1960s to make room for a housing development.

Potternewton Hall, Leeds

Originally the seat of the Mauleverers, Potternewton was later bought by the earls of Mexborough, who built the final hall in the early 1700s; it has been attributed to Henry Flitcroft. The grounds of Potternewton were said to be haunted by a spectral carriage. The house was demolished for residential building development. A panelled room from Potternewton was removed and is now the dining room at Sutton Park.

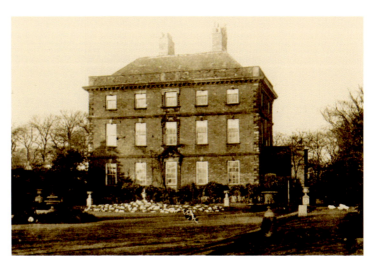

Potternewton Hall.

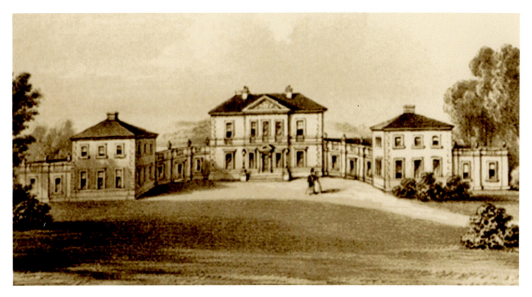

Pye Nest.

Pye Nest, Halifax

Pye Nest was one of architectural twins, both now lost (see Crow Nest). It was built in 1767 on the site of an earlier house for the Halifax merchant John Edwards; the architect was John Carr. The design was particularly elegant, the main block having a three-bay centrepiece under a pediment and one bay on either side. This block was connected by quadrants to three-bay by three-bay pavilions, each with a chimney at the apex of the pyramidal roof. One wing contained the kitchens, the other nurseries, a schoolroom and billiard room. The main rooms were arranged around a top-lit hall.

John Edwards came to the West Riding from Birmingham, married Elizabeth Lees and became a partner in her family's worsted mill. Edwards probably bought the estate in 1771. Pye Nest was eventually inherited by Sir Henry Edwards, on whose death in 1886 the estate was put up for sale. The house failed to find a buyer and was not finally sold by the Edwards family until 1932. Major A. H. Edwards was the last owner. The house was demolished and the land (134 acres at the end) was used for residential development.

Raisen Hall, Sheffield

In 1402 Raisen Hall belonged to John Hartley; the eponymous Raisen family followed. By the seventeenth century the hall belonged to the Wilkinsons of Crowder. In 1680 it passed by marriage to the Brights, who owned it until 1810 when John Deneton acquired it. His descendants occupied Raisen Hall until the twentieth century. The hall was demolished in the 1940s and the site is now occupied by a Tesco supermarket.

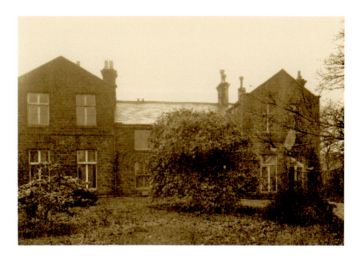

Raisen Hall.

Ravenfield Park, near Doncaster

Ravenfield was a large and unusual-looking house of eighteenth-century origin, on which John Carr worked around 1760. Estate deeds for Ravensfield date back to 1435, and the Westby family held it until it was sold by Wardell Westby in 1749. The purchaser was Elizabeth Parkin. Between 1749 and 1820 the house changed hands a number of times.

Carr's alterations were carried out for Walter Oborne, who had inherited Ravenfield in 1766 from his cousin Elizabeth Parkin. The Parkins had amassed a fortune from hardware manufacture in Sheffield and trading in London. Carr also built new stables and the nearby Church of St James.

The entrance front of the house originally had a three-bay centre with two-bay wings. The addition of three bays to the west side resulted in a distinctly lopsided appearance. The north side was unusual, with enormous gables stretching over the four bays at each end of the façade with a giant canted bay between them. There was a small circular window in each gable.

Oborne died childless in 1778, leaving the estate to Matthew Morgan, who preferred to live elsewhere. After Morgan's death in 1788 it passed to William Parkin Bosville, for whom Carr carried out further alterations. In 1820 Ravenfield belonged to James Birch of Thorpe Hall, Lincolnshire. Ravenfield was last occupied in the 1920s and was destroyed by fire in 1961. The stables survive and have been converted into houses.

Sandall Grove, Kirk Sandall

At the Conquest, the manor of Sandal was granted by William I to the de Warrenne family. The Rokebys were granted the property after Sir Thomas Rokeby defeated the rebellious forces of the Earl of Northumberland in 1400. The house dated from the seventeenth century. In 1776 Thomas Rokeby sold the house to the Martins of Barnby Dun, and the house was reconstructed around the turn of the eighteenth century. Sandall Grove was bought by Pilkington's glass manufacturers in 1920. In 1966 Dr and Mrs W. L. Patrick lived in the house. It was demolished shortly afterwards.

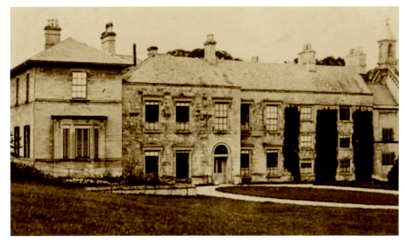

Scarthingwell Hall.

Scarthingwell Hall, Tadcaster

The core of the much larger house, demolished about 1960, was the seventeenth-century home of the Hammond family. The estate passed to Admiral Lord Hawke, who sold it to the Maxwell family in 1848. The Maxwells enlarged the house and built a Catholic chapel based on the Chapel Royal at Munich. The Maxwells sold the estate in 1948 and the house was demolished after some years as a ruin. The chapel, in an Italian Romanesque style, survives. A care home was built on the site of the hall in 2022.

Sheepscar Hall (Bischoff House), Leeds

Possibly the work of William Etty, Sheepscar Hall ended its days as an electrical show room. It was demolished in 1968.

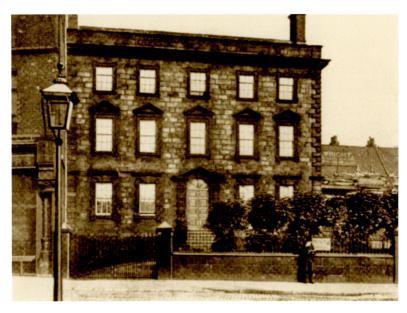

Sheepscar Hall.

Sheffield Manor, Sheffield

Little now remains of the manor that once belonged to the earls of Shrewsbury. Built around 1510, it was a rectangular building around a courtyard. Although only fragments of the main house still stand, Turret House, an Elizabethan summerhouse in the form of a three-storey stone tower with a higher brick angle turret, survives as do parts of the kitchens and gallery.

The manor was given to the de Lovetot family by William I and by 1200 they had built a wooden castle and a church. The de Furnivalls, lords of the manor of Hallamshire in the thirteenth and fourteenth centuries, rebuilt the castle in stone and gave Sheffield its town charter. The 1st Earl of Shrewsbury inherited the manor land and buildings through his wife in 1420. During the 1510s the 4th Earl built a major house, which accommodated Cardinal Wolsey when he visited in 1529/30.

Mary, Queen of Scots spent fourteen years (1570–84) of her incarceration in the custodianship of the 6th Earl of Shrewsbury at Sheffield Manor, and her ghost is said to haunt Turret House.

Shrewsbury undertook an ambitious rebuilding programme at the manor in the seventeenth century. The estate later passed by marriage to the Howard family, who usually lived elsewhere. The manor house was tenanted and demolished in stages from the early eighteenth century onwards. In the late nineteenth century, the 15th Duke of Norfolk restored what remained, and in 1953 the Norfolk estates granted a 999-year lease to Sheffield City Council.

Turret House is traditionally held to be the prison of Queen Mary, but its location within the complex makes this unlikely. The embattled building has three storeys with two rooms on each floor. The top-floor chamber has a fine original plaster ceiling and fireplace.

Shelf Hall, Bradford

Unusually among industrialists' houses, Shelf Hall, built 1861 for Samuel Bottomley, worsted manufacturer, was a grand baroque house with a portico and balustrade crowned with urns. The architect is unknown but may have been the local J. T. Fairbank. The house was later occupied by Bottomley's son Nathaniel. Used during the First World War as a prisoner-of-war camp, Shelf was later bought by Bradford City Council and demolished.

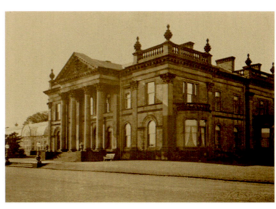

Shelf Hall.

Shuttleworth Hall, Allerton
The home of the Sunderland family, Shuttleworth Hall, built in the second quarter of the seventeenth century, had cross wings and a central two-storeyed hall from which the staircase opened. It has been demolished.

Skellow Grange (Newsome Grange), Burghwallis
Skellow was a seventeenth-century house remodelled in the following century by a member of the Higgins family. It had a five-bay centre with projecting wings, each of two bays. There was an arched window over the central entrance. The house had many owners, including Darcy Rawson in 1707 and W. H. Humble in the first half of the twentieth century. In 1964 the estate was bought by a farmer called Turnbull and the house was demolished. Skellow Grange was originally called Newsome Grange.

Springfield House, Wakefield
Springfield was built by Captain Ralph Hanson in the late eighteenth century. It was a very plain irregularly windowed stuccoed box with battlements hid a flat roof. Hanson's daughter Katherine lived at Springfield with enormous numbers of cats, each with their own bed, earning the house the name 'Cat Hall'. On Katherine's death in 1851 the property passed to the Ridsdales and Gledhills. Springhill has been demolished.

Sprotborough Hall, Sprotborough
The destruction of Sprotborough was one of the more serious losses amongst Yorkshire country houses. It was owned by the Fitzwilliams from the Norman Conquest until the reign of Henry VIII when it passed by marriage to the Copleys. The Royalist Godfrey Copley (created baronet in 1661) paid a fine of £1,543 in order to retain Sprotborough during the Commonwealth. In 1766 it passed through the female line to Joseph Moyle (a grandson of Sir Godfrey) who assumed

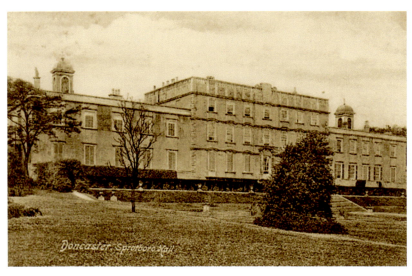

Sprotborough Hall.

the name Copley and was also created baronet. The final house was built in 1685 for Sir Geoffrey Copley Bt (son of the Royalist Sir Godfrey).

The hall had a three-storey seven-bay centre with two-storey five-bay wings that had been added by 1700, all on a terrace overlooking the river. On the entrance side there were corner towers with leaded cupolas. James Paine carried out some work at Sprotborough around 1750. The interior contained decoration by Laguerre. The whole exterior surface was harled during the second quarter of the nineteenth century, producing a rather bland and featureless exterior which belied the quality of what was inside.

Moyles descendants lived at Sprotborough until the death of Sir Joseph Copley in 1882. Sir Charles Watson, a descendant in the female line, then inherited and once again took the name Copley. The last Copley owner of the house was Robert Bewicke-Copley for whom the ancient title of Baron Cromwell was called out of abeyance, the last holder having died in 1497. Bewicke Copley sold the contents in the early 1920s and the house and estate in 1925. The house was brought by a Mr F. G. Cowland and demolished in 1926 – it was rumoured incorrectly that the house had been dismantled and shipped to the USA. The estate was also sold and used for residential development.

Stapleton Park, Darrington

Stapleton was acquired by the Savile family in the early sixteenth century. Subsequent owners included the Braithwaite, Greenwood Walker and Lowther families. Stapleton was bought in 1762 by Edward Lascelles, later 1st Earl of Harewood, and the house was immediately rebuilt or remodelled to designs by

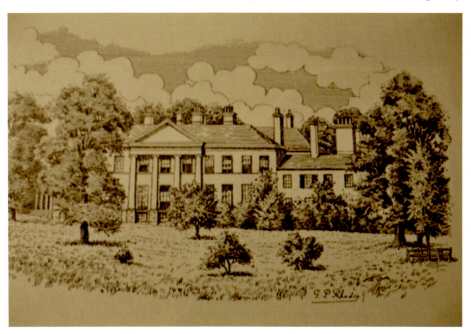

Stapleton Park.

John Carr. In 1789 the estate was sold to Charles, Baron Stourton and in 1800 to the 9th Lord Petre, who unfortunately died within a year of buying it. His son employed William Cleave to design alterations and additions, including a new Doric entrance portico. Petre was a successful racehorse owner and won the St Leger three times running from 1827 to 1829. Petrie built new stables at Stapleton Park, which were decorated with equestrian paintings by, amongst others, J. F. Herring. Petre sold the estate to the Barton family. Stapleton was demolished in the late 1930s.

Steeton Hall, Bilbrough
All that survives of the moated mansion of the Fairfax family, originally built by Sir Guy Fairfax around 1470, is one range with mullioned and transomed windows, which is now a farmhouse. Most of the remainder of what was once a substantial house was demolished in the early eighteenth century. The chapel survived until 1873. In a garden wall there is a thirteenth-century doorway and parts of the moat and several medieval fishponds also survive.

Strong Close House, Keighley
A vaguely French-detailed house for Keighley mill owner Joseph Craven, begun in 1864. Strong Close House was demolished in 1910.

Sutton Hall, Sutton-in-Craven
Sutton Hall didn't last long. It was designed by Samuel Jackson, built in the 1890s and demolished about 1940. The hall was built for the worsted manufacturer John Hartley, owner of Greenroyd Mill. In 1933 it was sold by the Hartleys to Ernest Turner and was for a time in multiple occupancy. The house was vaguely Elizabethan with a low belvedere over the entrance and bay window at each end of the façade. The site is now covered with more humble housing.

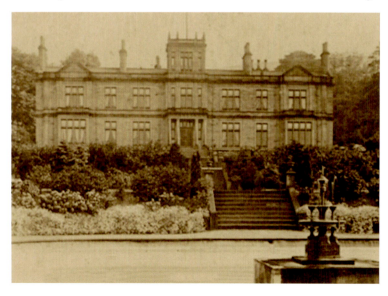

Sutton Hall.

Swillington House

After the Conquest, Swillington became the seat of the de Laci family, who took the name (de) Swillington. Sir William Lowther (the Lowthers had been seated since before the Conquest at Lowther, near Penrith) bought Swillington from Conyers Darcy in 1663. The gardens were remodelled in the 1730s. The estate then passed from father to son, all named William, until Sir William Lowther died without issue in 1763, leaving the estate to a cousin, Revd William Lowther, who also owned Alverthorpe. The Swillington estate passed to his eldest son, who became Baron and Viscount Lowther after the death of a distant cousin and was later created 1st Earl of Lonsdale. In the first quarter of the nineteenth century the new Earl of Lonsdale sold Swillington to his brother John, who was created baronet in 1824. Sir John served as one of Lord Lonsdale's pocket MPs – 'the Lonsdale ninepins' – and was succeeded in turn by his sons Sir John Henry (d. 1868) and Sir Charles (d. 1894), on whose death it passed to his grandson, Sir Charles Bingham Lowther, 4th Bt. Before his death in 1949, Sir Charles sold Swillington and his other local properties, moving first to Northamptonshire then to Denbighshire. The estate, which the Lowthers had always exploited for its coal, was sold to a colliery company. A new house had been built in the 1690s and this was remodelled by Henry Flitcroft in about 1738. Further extensions followed in 1803/04. After its sale, undermining led to demolition in 1950.

Tankersley Old Hall, Tankersley

Before the Norman Conquest Tankersley belonged to the Saxon noble Ledwin. William I gave the estate to Earl Meriton, following which it eventually came to the de Tankersleys. The estate passed by marriage to Elands in the thirteenth century, then to the Savile family as a dowry in 1375. The next owners were the Talbots, who owned it for eleven generations before it was sold to Thomas Wentworth, who became the 1st Earl of Stafford. The Old Hall was rented for a while to the Royalist Fanshawe family.

The Tudor house was largely demolished in the 1720s and the materials used to build houses on the estate. The ruins of Tankersley Hall stand 3 miles from Wentworth Woodhouse and were for many years part of the Fitzwilliam estates. John Carr designed a temple at Tankersley, presumably that later known as Lady's Folly. This too has been demolished. In the feature film *Kes* based on Barry Hines' novel, the hero Billy Caspar climbs the ruins of Tankersley Hall to take a kestrel chick from its nest.

Thornes House, Wakefield

Thornes House was designed in 1779 by John Carr as a five-bay, three-storey house with a central canted bay on the garden front. The entrance front was stone, the rest brick. Two wings – one of four bays, one of six – were added at a later date. It was commissioned by James Milnes, a cloth merchant, probably with the dowry from his immensely wealthy new wife. Thornes House was inherited by Milne's great-nephew Benjamin Gaskell and remained in the Gaskell family until 1919 when it was sold to Wakefield Corporation and used as a secondary school. Thornes was demolished in 1951 after a fire.

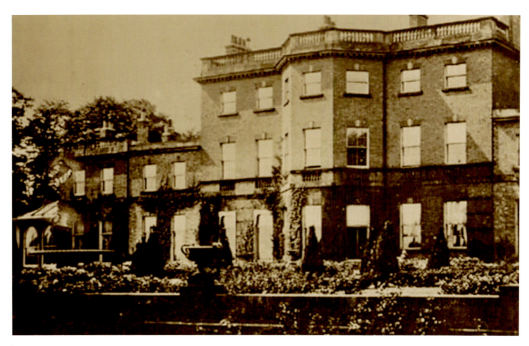

Thornes House.

Thorpe Salvin Manor House, Thorpe Salvin

Only fragments survive of Robert Smythson's house, built in the 1570s for Henry Sandford, the last in a long line of Yorkshire gentry, who died in 1582. The Sandfords had succeeded the Salvins as lords of the manor of Thorpe, and Sir Brian fought for Henry Tudor at Bosworth. A monument in the nearby church states that the Sandfords came from Westmorland in 1420.

Thorpe Salvin was sold to Sir Edward Osborne in 1636. Osborne was a Royalist and the house was stormed by Parliamentarian troops during the Civil War. It was abandoned after Thomas Osborne, Duke of Leeds, built nearby Kiveton Park, but appears to have remained intact into the nineteenth century. Most of the surviving buildings were demolished in 1820. The ruins of Thorpe Salvin, which are approached through a gatehouse with stepped gables, are now in the care of English Heritage.

Tingley Hall, Morley

Tingley was demolished in 1967 for road building associated with the new M62. In the nineteenth century it was the residence of the managers of Topcliffe Pit. Various owners followed including Andrew Brown Fraser and it was a camp for Italian prisoners of war during the Second World War. The hall was briefly flats before it was demolished.

Upper Shibden Hall, Halifax

Upper Shibden Hall dates from around 1800 and was built by the colliery owner and brewer Michael Stocks. An Italianate belvedere was added shortly after the

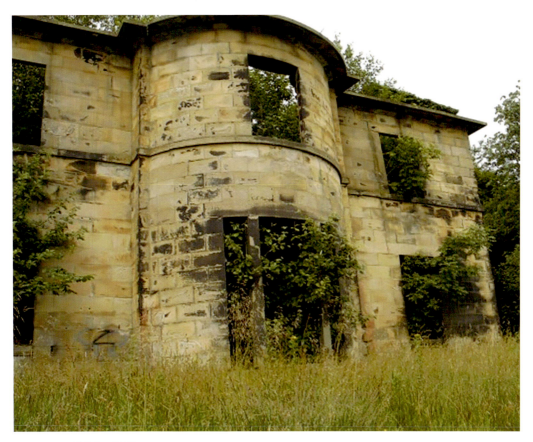
Upper Shibden Hall.

main block was completed. It was originally called Catherine House. Its burnt-out shell survives.

Walkley (Old) Hall, Sheffield
Walkley Hall was constructed by William Rawson in 1601. It was later divided into tenements and was demolished in 1926 to make way for new housing.

Walterclough Hall, Southowram
Walterclough Hall was originally built by the Hemingway family, who lived there from at least 1379 until 1654 when William Walker bought the hall. The house bore the initials of his second son, Abraham Walker and wife Anne. John Walker was the squire of Walterclough in the mid-eighteenth century and amassed a fortune as a wool factor. Walkers still owned Walterclough in the late eighteenth century. By 1870 Walterclough Hall had become a boarding school for young ladies, but by 1913 it was almost unoccupied and in an advanced state of decay. During the Second World War its windows were shattered by a German bomb dropped nearby, and by the early 1970s only a fragment of Walterclough Hall remained standing. This was demolished in the late 1970s.

Wardsend House, Sheffield
Wardsend, which was built for the Rawson family and demolished in 1957, was a rather impressive classical villa of three floors and seven bays, the middle three projecting slightly under a triangular pediment.

Warley House, Halifax
Warley House was built in 1769 by a Mr Cook. It was bought in 1866 by the wealthy damask manufacturer H. C. McCrea, from whom it passed to his son A. S. McCrea, who bequeathed it on his death in 1945 with an endowment of £50,000 to the Royal Halifax Infirmary. McCrea also bought Shibden Hall and gave it into public ownership. On the establishment of the NHS no use was found for the house, and it gradually fell into disrepair and the extensive grounds were sold off. The hall was demolished in 1964. In 1994 Paul and Catherine Hinton bought the gardens, which they have restored, building a new house on the site.

Water Royd Hall, Mirfield
Water Royd Hall is most famous for the murders that took place there in 1847. A monument to the victims stands in the graveyard of the Baptist Chapel. The hall has been demolished and its site used for housing. James Wraith, his wife Ann, and their servant Caroline Ellis, respectively aged seventy-eight, sixty-five and

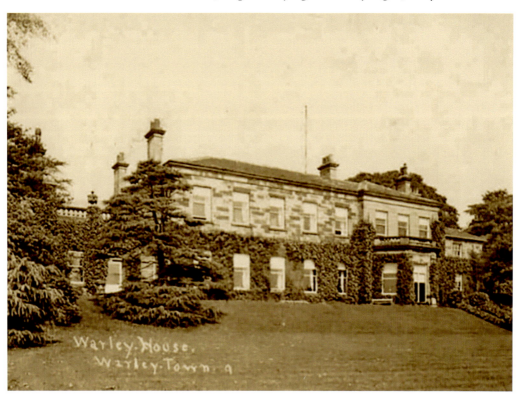

Warley House.

twenty-one, were found by the Wraiths' great-nephew in a pool of blood. Caroline Ellis had had her brains dashed out and her throat cut; Mrs Wraith was dead and in a mutilated state; and Mr Wraith had had his head crushed and his throat cut from ear to ear. An Irishman, Patrick Reid, was hanged for the murders at York in 1848 and his accomplice, Michael McAbe, was transported. As a contemporary poem described it:

> Night is the Murd'rer's fittest time, but this fell deed was done,
> Not in the shade of mid-night gloom, but 'neath the noon-day sun,
> Not in the silent hour of sleep, when mortals cease from strife,
> But midst the cheerful din of day- the teeming tide of life.
> When I beheld thee hush'd in death (a smile was on thy brow,)
> Methought I heard thee sweetly say, 'you cannot harm me now;')
> O had thy Murd'rer seen thee, like a lovely child at rest,
> What barbed arrows must have pierced the villain's guilty breast...

Well Head, Halifax

Well Head was once the seat of the Waterhouse family, who were cloth merchants responsible for the early development of Halifax as a weaving town. The final hall was built following the marriage of John and Elizabeth Waterhouse in 1767. The house has been convincingly attributed to John Carr and was of five bays and two and a half storeys. It was demolished in 1976.

Westfield House, Balby

Westfield was an early nineteenth-century villa. From 1824 to 1835 it was the residence of Frederick Fisher, town clerk of Doncaster, and later of his son, whose widow outlived him for many years. In 1913 the Westfield housekeeper interrupted supporters of women's suffrage in an attempt to burn the house down. In 1937 the estate was acquired by Doncaster Corporation and the house demolished. The grounds became a public park.

Weston Hall, Sheffield

Sheffield Corporation purchased Weston Hall and its grounds for £15,750 following the death of the owners, Eliza and Anne Harrison, daughters of a saw manufacturer, to create the city's first municipal park. The hall itself was converted into the Sheffield City Museum but has since been demolished and replaced.

Wetherby Grange, Wetherby

Also known as Micklethwaite Grange and Beilby Grange, Wetherby Grange was first built in the seventeenth century by the Beilby family. Alterations were made in the eighteenth century by one of the Wyatt dynasty and John Carr. The Grange was distinguished by a round tower in the centre of the entrance front, topped by a shallow dome. In its final form it was built for Bielby Thompson, whose main seat was at Escrick. The estate was sold in 1856 to Colonel Sir Robert Gunter, who moved in on his return from the Crimean War. The house was sold again in 1942 and finally demolished in 1962.

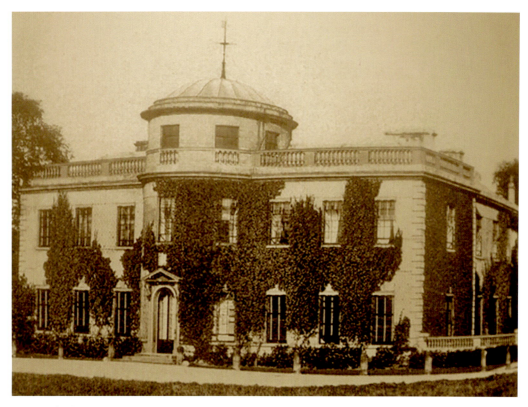

Wetherby Grange.

Wheatley Hall, Doncaster

Wheatley was built by Sir Henry Cooke around 1680 and remained the seat of the Cookes until early in the twentieth century. The last Cooke to live there was Sir William Wemyss Cooke, who left in about 1914 to be nearer his colliery in Bentley. In 1913 suffragettes attempted to blow up the empty hall. During the First World War, Wheatley was used by the military. It was later leased by Sir William to Wheatley Golf Club and the hall used partly as flats and partly as a clubhouse, the park becoming a golf course. The club moved to Armthorpe in the early 1930s and the house was sold to Doncaster Corporation in 1933.

A classical house of four storeys and nine bays with large windows, Wheatley was demolished in 1938 when the staircase was removed to Hurstmonceux. The site has been taken over by industry.

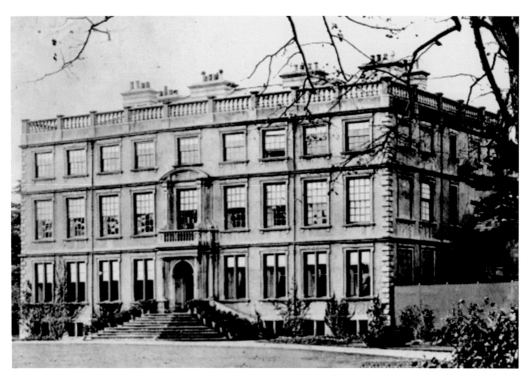

Wheatley Hall.

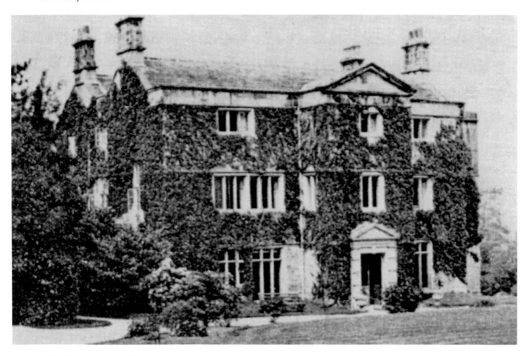

Whiteley Wood Hall.

Whiteley Wood Hall, Sheffield

Whiteley Wood was built by in 1662 by Alexander Ashton. The Ashton family conveyed the hall to Strelley Pegge of Beauchief Hall in 1741 and he in turn sold it to Thomas Boulsover, inventor of Sheffield plate, who died at Whiteley Wood in 1788. When Boulsover's great-grandson died in 1861 the estate passed to a distant relative. Between 1864 and 1876 Whitely Wood was the home of Samuel Plimsoll MP, 'the Sailors' Friend'. Sheffield Corporation bought the hall in 1896, although Arnold Muir lived there until 1909. Between 1911 and 1926 the hall was rented by William Clark, managing director of the Vickers steel firm. By the end of the 1930s it was in very poor condition. In 1935 it was purchased by the Sheffield Girl Guides but continued to decay. In 1936 the roof was removed and in 1959 the hall was demolished. Whitely Wood was a complex building of a variety of dates. Sir Jeffrey Wyatville carried out alterations in 1822. The stables survive.

Whitley Beaumont, Kirkheaton

Whitley Beaumont was the seat of the Beaumonts from the thirteenth century. The direct male line failed in the mid-nineteenth century when the estate was left to Henry Frederick Beaumont of Newby Park, Ripon, who gave Beaumont Park to the Corporation of Huddersfield: 'Public parks are necessary for large and populous towns to increase the happiness, promote the good health and elevate the minds of the people.' The line failed again with the death of his son Ralph Henry in 1948.

An older hall was rebuilt in the mid-sixteenth century, with a great hall and projecting wings forming a U-shaped courtyard. Beginning in 1704, the open side of the courtyard was closed and a new baroque front added A stone arcade

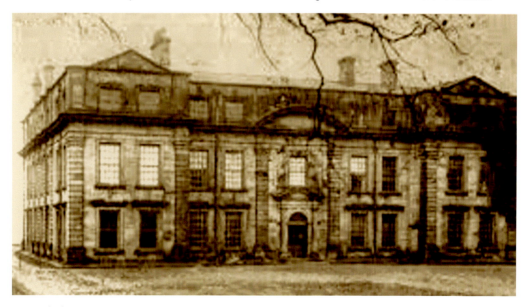

Whitley Beaumont.

connected the rooms round the court. The great hall was remodelled for Richard Beaumont in the 1750s by his brother-in-law James Paine. A gazebo (now ruined) near the house was probably also designed by Paine, and Capability Brown worked on the grounds.

Beaumont's fittings were sold at auction in 1917. The house was bought by Charles E. Sutcliffe in 1924 but was sold by T. Reginald Sutcliffe in 1950 to property developers, who broke up the estate. The park had already been requisitioned for opencast coal mining and the house was demolished in 1950. An exquisite classical temple survives in poor condition.

Wighill Park, Wighill

Formerly the seat of the Haget and Turet families, Wighill was acquired by the Stapletons in the late fourteenth century. The Stapletons built themselves a new manor house, which was in turn rebuilt by Sir Robert Stapleton in 1580. In the late eighteenth century the heiress to the estate, Martha Stapleton, married Captain Granville Chetwynd, who assumed the name Chetwynd-Stapleton and built the third Wighill Park. In 1811 the house was sold to Fountayne Wilson MP

Wighill was later tenanted by the lords Hawke who extended the house. The 7th Lord Hawke left Wighill in 1924. In the 1950s the estate was broken up and the house partially dismantled. The shell was bought by an architect who built a new residence within the ruins. The stable block survives.

Wigtwizzle Hall, Ewden Valley

The delightfully named Wigtwizzle Hall was demolished in 1923 and the stone used to build houses near Morehall for the Water Board. The gateposts survive. In 1623 Mary, daughter of Revd John Ibbotson of Wigtwizzle, married Christopher Wilson of Broomhead Hall.

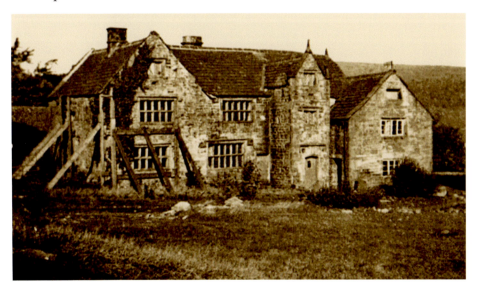

Wigtwizzle Hall.

Wincobank Hall, Sheffield

Le Wynkeabankce was first recorded in 1574. Wincobank, which was built in 1760, was demolished in 1925/26. The earliest recorded owner was John Browne in 1713, whose wife Martha Staniforth had inherited the property. The hall was built by John Sparrow, who married Lydia Browne, John Browne's daughter. In 1816 Joseph Read bought the hall and the last private resident was his daughter Mary Ann Rawson, who bought it in 1837 from her father's bankrupt estate as a home for her widowed mother and unmarried sisters, who ran a school there. The Reads were prominent in the campaign to abolish slavery. Wincobank became a Salvation Army Women's Industrial Hostel and was a children's home for five years before its demolition. Council houses were built on the site.

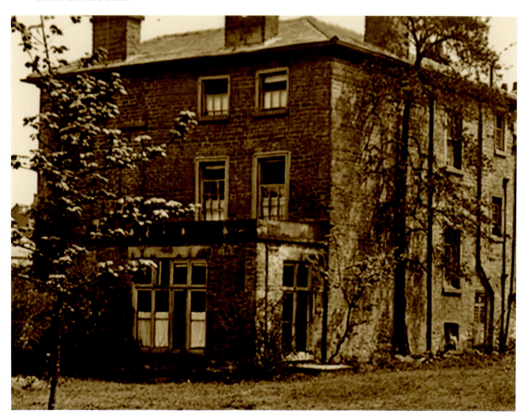

Wincobank Hall.

Wombwell Hall, near Barnsley

Wombwell was the seat of the Wombwell family for 500 years from the thirteenth century. The last in the male line was William Wombwell, who died in 1733 leaving two daughters. The house and most of the estate was bought by a cousin, the nabob George Wombwell, who didn't live in the house; instead, it was let. It gradually fell into disrepair and was demolished. The Wombwell baronets are now seated at Newburgh Priory. On Easter Sunday 1531, Henry, the lord of the manor of Wombwell, called for a cup of ale after church and died shortly afterwards, the ale having been allegedly poisoned by his wife and a servant. No one was ever bought to trial for the crime.

Woodlands, Girlington

Woodlands was designed by Milner and France in the 1860s for Angus Holden, mayor of Bradford and later 1st Baron Alston. Additions were made by the same architects in 1876, including a music room with stained glass by Burne-Jones. Woodlands was a dramatic Gothic house with a tower over the entrance containing an observatory. It has been demolished.

Woodthorpe Hall, Sheffield

Woodthorpe Hall was the seat of the Parkers from the mid-eighteenth century. They were followed by the Gainsford family. Woodthorpe was demolished in 1934 to make way for housing and a school.

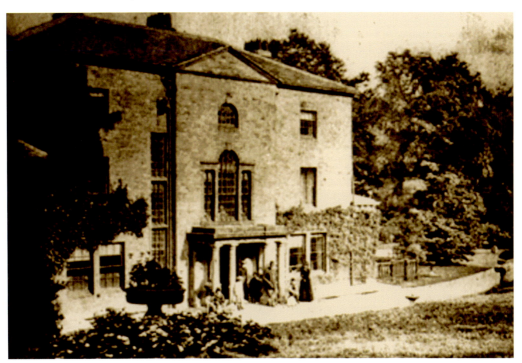

Woodthorpe Hall.

Bibliography

Books

Ambler, Louis, *The Old Halls and Manor Houses of Yorkshire* (BT Batsford: London, 1914)

Anginotti, S. (ed.), *It Was All Country Then: A History of Southey & Longley From Fields to Estate* (Southey & Longley Local History Group, 1980)

Armstrong, B. and Armstrong W., *The Arts and Crafts Movement in Yorkshire: A Handbook* (Oblong, Wetherby, 2013)

Burke's Peerage, Baronetage and Knightage, 107th edition

Burke's Peerage and Gentry LLC (Wilmington Delaware, 2003)

Cahill, Kevin, *Who Owns Britain?* (Canongate: Edinburgh, 2001)

Cornforth, John, *The Inspiration of the Past* (Viking, 1985)

Evinson, Denis, *The Lord's House: A History of Sheffield's Roman Catholic Buildings 1570–1990* (Sheffield Academic Press, 1991)

Fletcher, J. S., *Memorials of a Yorkshire Parish* (John Lane, The Bodley Head, 1916)

Gliddon, Gerald, *The Aristocracy and the Great War* (Norwich: Gliddon Books, 2002)

Haward, Winifred, *The Secret Rooms of Yorkshire* (Clapham: Dalesman Publications, 1956)

Healey, Edward, *A Series of Picturesque Views of Castles and Country Houses in Yorkshire* (Bradford: Thomas Shields, 1885)

Hebden, W., *Famous Yorkshire Homes* (North Yorkshire: Dalesman Books, 1974)

Hey, David, *Buildings of Britain 1550–1750: Yorkshire* (Derbyshire: Moorland Publishing, 1981)

Hey, David, *A History of Yorkshire* (Lancaster: Carnegie Publishing, 2005)

Kluz, Ed, *The Lost House Revisited* (London: Merrell, 2017)

Morris, Richard, *Yorkshire* (London: Weidenfeld and Nicolson, 2018)

Pevsner, Nikolaus, *The Buildings of England: Yorkshire: The West Riding*, 2nd Edition (London: Penguin, 1967)

Pevsner's Architectural Glossary (Yale University Press, 2010)

Redfern, Roger, *Sheffield's Remarkable Houses* (Chesterfield: The Cottage Press, 1996)

Royal Commission on the Historical Monuments of England (Rural Houses of West Yorkshire, HMSO London, 1986)

Ryder, Peter F., *Medieval Buildings of Yorkshire* (Ashgrove Books, 1993)

Salter, Mike, *Castles and Tower Houses of Yorkshire* (Malvern: Folly Publications, 2001)

Sheeran, George, *Landscape Gardens in West Yorkshire* (Wakefield Historical Publications, 1990)

Sheeran, George, *Brass Castles: West Yorkshire New Rich and their Houses 1800–1914* (Gloucestershire: Tempus, 2006)

Strong, Roy, *The Destruction of the Country House* (London: Thames and Hudson, 1974)

Taylor, Alfred, *Yorkshire Castles* (Yorkshire Evening Post, 1963)

Tuffrey, Peter, *Doncaster's Town and Country Houses (Images of England)* (Gloucestershire: Tempus, 2000)

Waterson, Edward and Meadows, Peter, *Lost Houses of the West Riding* (York: Jill Raines, 1998)

Willis, Ronald, *Yorkshire's Historic Buildings* (London: Robert Hale, 1975)

Wood, G. Bernard, *Historic Homes of Yorkshire* (Edinburgh and London: Oliver and Boyd, 1957)

Worsley, Giles, *England's Lost Houses from the Archives of Country Life* (London: Aurum Press, 2002)

Newspapers and Periodicals

Bradford Telegraph and Argus
British Archaeology
Craven Herald
Daily Mail
Daily Mirror
Daily Telegraph
Dales Life
Doncaster Free Press
Evening Chronicle
Halifax Courier
Harrogate Advertiser
Horse and Hound
Huddersfield Daily Examiner
Ilkley Gazette
Mail on Sunday
Northern Echo
Pontefract and Castleford Express
Sheffield Star
Sheffield Telegraph
Sunday Telegraph Magazine
Telegraph and Argus
The Times
Todmorden News
Wakefield Express
Yorkshire Evening Post
York Evening Press
York Press
Yorkshire Life
Yorkshire Post
Yorkshire Ridings Magazine

Illustration Credits

Many of the illustrations are from my own collection. I hope I have mentioned everyone who kindly agreed to provide images; if not, I will gladly make amends in future editions. Similarly, if I have unknowingly used copyright material, I can only apologise.

Thank you again to Matthew Beckett of Lost Heritage for his continuing kindness in allowing me to reproduce the following illustrations from his website: Alverthorpe Hall, Badsworth Hall, Bierley Hall, Caley Hall, Chevet Hall, Cragg Hall, Denby Grange, Flasby Hall, Hague Hall, Harrowins, Heaton Hall, Methley Hall, Newall Old Hall, Park Hill House and Thornes House.

Sheffield has seen the greatest losses amongst its houses of the cities of the North East and I am immensely grateful to Graeme Siddall and his colleagues at Sheffield City Archives for their kind assistance in providing the following illustrations from the their collections (Picture Sheffield): Bell Vue House, Cliffe House, Crowder House, The Farm, Fieldhead House, Hallam Gate, New Hall Attercliffe, Norton Wood Hall, Norwood, Raisen Hall, Wigtwizzle Hall and Woodthorpe Hall.

The photograph of Wincobank Hall is reproduced by kind permission of Bryan Woodriff, whose kindness I would like to acknowledge. Thank you to Stephen Richards for the image of Milnsbridge House. John Wilkinson was most generous in providing information relating to Horton Hall.

My sincere thanks are due to Steve Hyde from Friends of Queen's Park for the illustration of Kippax Park and for providing other information.

Thank you also to Carol Hill of Doncaster Library Services for images of Barnbrough Hall, Beechfield House, Hatfield House, Sprotborough Hall and Wheatley Hal, and to Leeds Libraries and Information Services (Alwoodley Old Hall, Horsforth Hall, Howley Hall, Killingbeck Hall, Knowsthorp, Potternewton Hall, Sheepscar Hall, Wetherby Grange).

Doncaster Library Services kindly located the photographs of Carr House, Dunscroft Abbey, Edenthorpe and Finningley Hall. Chris Hobbs generously provided the photograph of Lydgate Hall.

Thanks to Tadcaster Historical Society and Peter Bradshaw for the picture of Healaugh Hall. And to Trudi Pankhurst Green and BMC History and Heritage Group archive, who kindly provided the illustration of Crookhill.

Rotherham Archives and Local Studies Centre generously provided the illustrations of Aldwarke Hall, Hooton Levittt Hall, Hooton Roberts Hall, Ickles Hall and Eastwood Hall. I am also most grateful to Adrian Sill of Donny Online, who very kindly provided the image of Campsall Hall.

I am also grateful to Richard Lee-Vanden Daele and R. David Beale for information regarding Milner Field, and to Kelly Oxley and Crow Nest Golf Club for the illustration of Crow Nest.

The illustration of Howarth Hall is reproduced by courtesy of Mike Stow and the webmaster of the Rotherham unofficial website.

The illustrations of Binroyd Hall, High Sunderland, Liversedge Lower Hall, Norland Upper Hall are from Ambler.

As far as I have been able to establish, the illustrations of Ackworth Park, Darnall Hall, Darnall Old Hall, Manor Heath, Milner Field, Parlington and Whitely Wood Hall are in the public domain.